THE PHOTOGRAPHER'S GUIDE TO

Making Money

150 Ideas for Cutting Costs and Boosting Profits

Karen Dórame

AMHERST MEDIA, INC. ■ BUFFALO, NY

About the Author

As a trainer for Special Kids Photography of America, Karen Dórame teaches workshops to attendees whose proficiency levels range from just entering the professional scene, all the way up to Master Photographer and Craftsman level. Questions asked by those new to the business led Karen to explore the challenge of collecting helpful money-saving (resulting in money-making) advice from skilled professionals who have learned the business through years of schooling and experience.

View the companion blog to this book at: http://photoguidemoney-dorame.blogspot.com/
Check out Amherst Media's other blogs at: http://portrait-photographer.blogspot.com/
http://weddingphotographer-amherstmedia.blogspot.com/

Published by:
Amherst Media®
P.O. Box 586
Buffalo, N.Y. 14226
Fax: 716-874-4508
www.AmherstMedia.com

Publisher: Craig Alesse
Senior Editor/Production Manager: Michelle Perkins
Assistant Editor: Barbara A. Lynch-Johnt
Editorial Assistance by John S. Loder and Charles Schweizer.

ISBN-13: 978-1-58428-257-0
Library of Congress Control Number: 2008942243
Printed in Korea.
10 9 8 7 6 5 4 3 2 1

Contents

Front cover—*Teen model Kailee Gow was photographed as part of a lighting class led by Carl Caylorat Image Explorations, a PPA Affiliate School in Victoria, BC. Photo by the author.* **Above**—*A great hat collection can decrease your costume or wardrobe costs. See tip #137 for more money-saving, wardrobe building strategies. Photo by Stacy Bratton.*

Clever birth announcements make great add-on portrait products that will increase your profits. Photo by the author.

Use simple artistic enhancements to take your portraits from ordinary to extraordinary and watch your profits grow. Photo by the author.

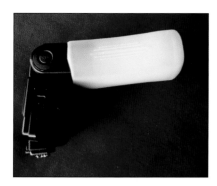

You can create this light modifier for less than a dollar. See tip #64 for details. Photo by the author.

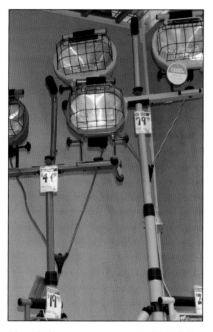

Shop lights can serve as studio lighting units when coupled with light modifiers. Photo by the author.

Flea-market finds make fabulous portrait props. For other seating ideas, see tip #138. Photo by the author.

Make a great impression with clients by sending them out the door with beautifully presented photographs. See tip #148 for more information. Photo by the author.

Specialize in a genre.

There are numerous areas of specialization in professional photography: senior portraits, commercial photography, fashion photography, weddings, fine art, children's portraits—the list goes on and on! The one rule you can count on, though, is that you won't be successful if you try to do them all. At most, you can probably be a real success in two or three areas. Specializing will give your business direction and allow you to spend your time

Lisa Jane Murphy is known for her fantasy sets and angelic portraits.

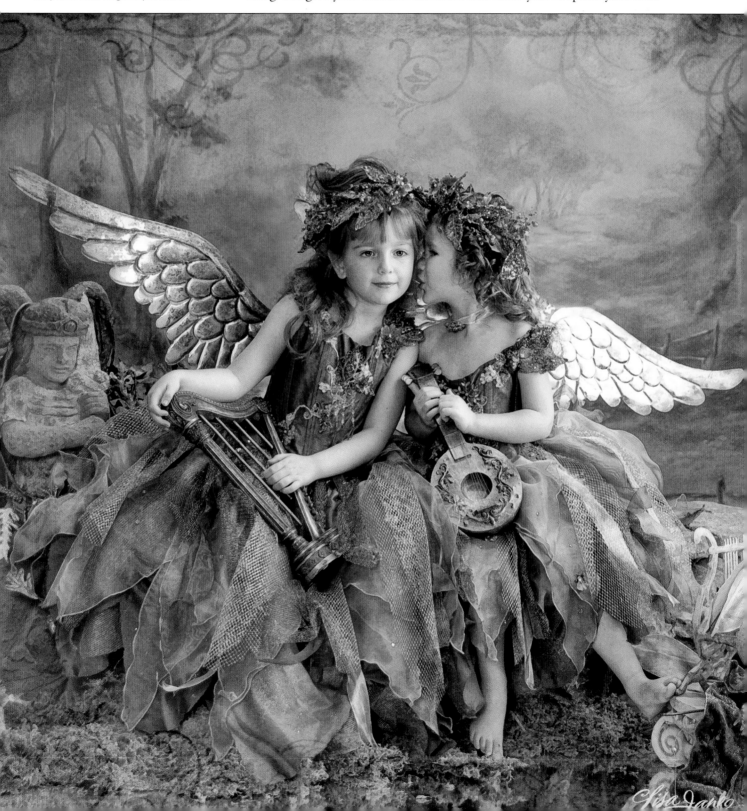

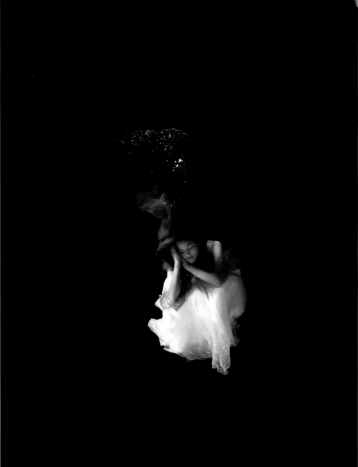

doing what you love most. Martha Fitzsimon, quoted in *Professional Photographer Magazine* (July 2006, p. 31), said, "[I wish I would have known] the importance of focusing my business [on a particular genre]. I wouldn't have spent a year doing other kinds of photography that weren't me." To see some of Martha's work, visit www.marthafitzsimon.com.

Make the most of your abilities.

Specialization doesn't mean you have to do the same thing day after day, only that there's a specific genre where you focus most of your efforts. For example, Elizabeth Homan spends most of her time running a successful San Antonio, TX, family-portrait studio called Artistic Images (family portraiture is a significant bread-and-butter area in professional photography). However, she occasionally takes leave from her studio to pursue one of her other passions: teaching. She has become a popular photography instructor, providing practical advice on what she does to obtain an average sale of over $4,000 from a family session.

Don't try to fit a square peg in a round hole.

Before you decide on a genre of specialization, think it through carefully. Some people feel that wedding photography is the logical first step in building a business. Though it's true that high-end wedding photographers can profit greatly from their work, they are only able to do so because they possess the special convergence of personality, talent, magnetism, and drive that is required. As a result, even many well-established and highly re-

Elizabeth Homan's high-grossing studio focuses mainly on family portraiture. Photo by Artistic Images—Portraits by Elizabeth Homan.

spected studios do not cover weddings. (On the other hand, Mike Colón, from Newport Beach, CA, is an excellent example of a wedding photographer who has achieved astounding success in his field. You can learn about him at www.mikecolon.com.)

So, figure out where your passion and abilities really point you. Are you a technical whiz who would enjoy crafting meticulous lighting setups for product photography? Do you have the stamina and patience to spend your days chasing high-energy toddlers around a set? Can you see yourself pumping adrenaline every day while covering fast-paced events, calming an anxious bride, or acting as mediator for hostile mothers in law?

TIP #4

Consider unexpected specializations.

Be creative when thinking of genres that might interest you. "School photography is one of the biggest money-makers in the industry," says Scott

Top—If your passion is children's photography, be sure to involve all the kids as a group, then separately. You'll likely command higher profits. Photo by the author. *Bottom*—Leg? I'll Show You Leg is a playful pet photo that is sure to appeal to the entire family. Photo by the author.

Dina Ivory's high key style is polished and professional.

Kurkian, CFO of the Professional Photographers of America (PPA). Although this specialty may not be as creative and as easy to break into as portraiture, there is a constant need. (*Note:* One way to "break in" with a school is to offer unique and compassionate photographic services to their children in special education classes.)

TIP #5

Develop a unique style.

Whether photographing fashion models, families, architecture, or pets, professionals become known for their specialty. However, clients also seek out particular photographers because of their unique style. Evaluate the competition in your market and see what you can do differently, how you

can stand out. Perhaps yours is the only studio photographing babies and young children against black backgrounds. Maybe you offer the most glam-oriented senior portraits. Or maybe you offer unique locations or backgrounds for your portraits—something clients can't get anywhere else. As Gregory Heilser said in *Professional Photographer Magazine* (Jan. 2007, p. 125), "Ultimately, the best price protection someone can have is being unique. When people follow trends and their style becomes less definable, it fuels their doom."

Whatever your specialty, visit the web sites of all the photographers doing the same type of work that you can Google up. Experience the excitement when viewing the excellent work of photographers who are masters in their own imaging specialties. The list below is a good staring point for your search.

Learn from the Masters of the Craft

Angels and fairies—Lisa Jane Murphy (www.lisajane.com)

Celebrity—Amy Cantrell (www.amycantrell.com)

Children and family portraiture—Sandy Puc' (www.expressionsphotos.com)

Commercial photography—Dave Montizambert (www.montizambert.com)

Documentary portraiture—Trish Reda (www.trishreda.com)

Fashion, glamour, avant garde—Cherie Steinberg Coté (www.cheriefoto.com)

Still life—Jim DiVitale (www.divitalephotography.com)

Landscape—Jeremy Turner (www.jturnerphotography.com)

Mothers and babies—Ana Brandt (www.anabrandt.com)

Pets—Bryant Dog Photography (www.bryantdogphotography.com)

Portraitist style—Arthur Rainville (www.studiorainville.com)

Senior portraits—John Ratchford (www.ratchfordphotographic.com)

Special children—Laura Popiel (www.laurapopielphotography.com)

Sports—Brad Mangin (www.manginphotography.com)

Weddings—Doug Gordon (www.patkenphotographer.com)

TIP #6

Plan for success.

Whether you want to start a photography business or grow the one you already have, you need a personal plan that embraces your vision and goals. This involves arranging for the time you need to create your photography, manage and promote your business, and continue your education about all aspects of the profession—all while dealing with other demands in your personal life. Once your personal plan is established, you can develop a business plan to ensure your success. Only when both plans are in place will you be ready to wear the professional badge.

TIP #7

Impress yourself!

If you need a little kick start, get busy and create some really impressive images. This will build your confidence and enthusiasm. To create a constant reminder of your art, have professional prints made of your best work and hang them all around your home—especially in the entry hall, where guests will be charmed with your imaging abilities.

TIP #8

Promote your work to those around you.

You probably won't hear this simple marketing idea in a professional workshop; it is so low-key. For timid souls (and those who still have other jobs), though, the "look what I have to show you!" method is a great way to get started.

Start by creating a portfolio of your best images, showcasing your unique style—the special "look" you want to use to draw in clients. This album should feature one large (at least 8x8-inch), professionally printed photograph per page. Shop around for a classy album; your work must stand out as a formal volume of professional samples, not a scrapbook. Professional album companies await your business and can create wonderful products for established photographers. If you are new to the field and likely to replace your "start-up" photos with improved images, select a portfolio album with "lay flat, slip-in" plastic casings. The flat pages will allow you to view images on a flat plane, and the opening will allow you to change out the photos as your work improves.

Once you have completed this showpiece collection, take it with you wherever you go. Get excited! Share that excitement with everyone you know.

An album with a consistent image style will create a more professional impression than one filled with a variety of looks, picture sizes, and image effects. Album pages with slip-in photo mats or plastic casings facilitate changing and updating images. Photo by the author.

TIP #9

Bring in volunteers as models.

Announce to acquaintances that you are looking for models who will pose for your portfolio—or, for more established photographers, for test shoots that will allow you to experiment with new techniques in a casual setting (before you integrate them into sessions with paying clients). After the session, invite your volunteers to watch a slide show presentation of your finished images so they can select a free 8x10 as a thank-you gift. Have a price list ready so you can take orders for any additional images they would like to purchase.

TIP #10

Clearly define your fees when you become a paid professional.

If you are a new professional, your first assignments will likely come from friends and family. If you're not careful, this can be a rocky road. Woeful is the too-familiar tale of a new pro photographer who was excited to be asked by a friend to photograph a family reunion. The only thing the photographer forgot to mention was that he had since turned professional and was now charging for his services. Imagine the surprise when the unsuspecting client (i.e., "former friend") got a bill along with the prints. Needless to say, this sort of scenario will create hurt—even enraged—feelings. New pros must find a polite way to disclose their recently adopted professional status with acquaintances and relatives. The best way to avoid disaster is by meeting ahead of time to discuss the session as well as the fees. Ask for a prepaid session fee, just as you would with any other client.

ANNOUNCE TO ACQUAINTANCES THAT YOU ARE LOOKING FOR MODELS WHO WILL POSE FOR YOUR PORTFOLIO.

TIP #11

Compare your work to that of other artists.

Don't be afraid to get out there in the photo world and stare—it's not as though you are in a locker room with a bunch of naked bodies! Study the works of professionals whose web sites are listed in this book. Their names may not be as famous as Ansel Adams', but their work is worth investigating and comparing with yours. Know what it takes to emulate the work of a great photographer.

TIP #12

Know what a technically correct image looks like.

Prior to focusing on developing a unique style, you must make certain your photographs are technically correct. Don't ever compromise when it comes to quality. Make each photograph stand out from the pack with superb

Weddings are not a good place to start practicing your craft. Images from this memorable chapter in life's journey will be family treasures. These photos must be of the highest quality. Photos by the author.

lighting and all-around technical excellence. (For some great examples of top-quality photography, check out the work of Stephanie Clark and Jen Hillenga.)

We all thrill ourselves with our own work. Unfortunately many newcomers to the magical world of photography are blissfully unaware of what constitutes a quality photograph. Listen and learn from experts at photography conventions and workshops before attempting to sell your work to clients.

Today's clients are very savvy about photography, so don't presume that *they* don't know what to look for in a professional-quality image. The digital era has taken much of the mystique out of photography. As a result, you'll probably encounter clients who know just as much about your camera and computer software as you do.

TIP #13

Master your craft.

The professional photographer is always learning, experimenting, and pushing his or her craft to greater heights. "Professional photographer" is a unique title that identifies a person who has skills somewhere between an artist and an astronaut. Although a certain amount of fantasy and experimentation is involved in reaching for the stars, technical training is a key element to success, whether you are striving for your personal best or world renown.

Artist Gigi Clark of Oceanside, CA, serves as a perfect example of such a practitioner. She yearns to explore and create, traveling far beyond conventional standards in photography. Says Gigi, "I do not break rules for the arts until I have learned them well. In photography, I have broken many rules of the craft, embracing all that I know and implementing it in my work."

Anyone who thinks they can start a photography business based solely on their love for taking pictures may be disappointed when presenting themselves to the general public. One needs more than passion to succeed in today's highly competitive imaging world.

TIP #14

Practice is the cheapest training.

No amount of classroom training is as beneficial as practice with your camera. Take your camera with you wherever you go, and use it at every opportunity! Acclaimed photographer and photo instructor Tony Corbell recommends, "Set up daily photo challenges for yourself [especially when on vacation]. For instance, go out and find interesting objects that form

Gigi Clark's In the Manner of Gauguin *is an art piece, pregnant with symbolism about childbirth.*

Above and left—Tony Corbell, well-known photo convention presenter, recommends a constant persuit of practice and skill development. While on vacation, set up daily photo challenges that will keep your mind attuned to spotting an extraordinary photo opportunity—even in the ordinary. Run through the alphabet for your daily dose of vitamins. The author found these A-B-C images in hanging travel bags (A), roof tiles (B), and the handle of a restroom door (C). ***Facing page***—*Jon Haverstick constantly hones his craft through practice. One day, he walked by a welding business, and the desire to capture this image became irresistible. Moments like this make keeping a camera nearby worthwhile.*

the letter *A*. Photograph your way through the alphabet." Jon Haverstick, a professional photographer and classroom instructor from Santa Ana, CA, e-mails his latest "photo finds"—often interesting photos he visualizes in ordinary objects—to friends and relatives every week. (Thank goodness for digital photography. Otherwise, his film bills would be staggering!) By developing this habit, he constantly hones his craft through practice.

TIP #15

Make yourself worth your fee.

Consider what should go through a professional photographer's head when on location with a teenager who is looking for a series of creative

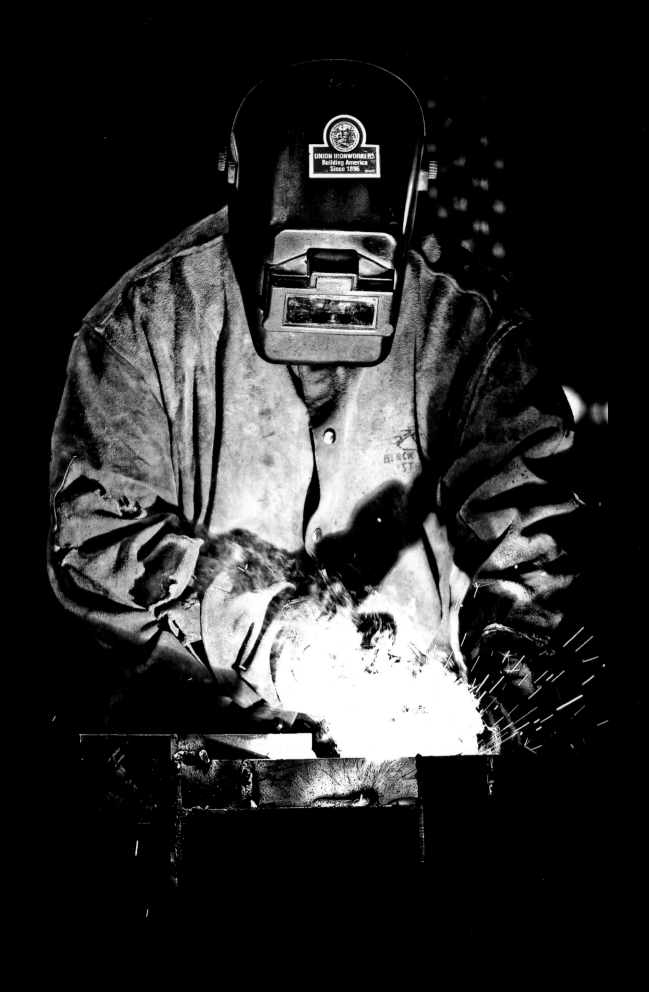

To successfully capture this senior portrait, Laura Popiel had to work through all of the questions listed in tip #15.

senior portraits: What can I say to make the subject relax? Where is the light coming from? How can I be creative with this session? What unusual props are nearby? Where are the best background opportunities? Does the shot need backlighting? Are there unwanted shadows created under the nose, eyes, or immediately behind the subject? Are the hands and fingers

posed correctly? Is there enough space around the subject in the frame? Is the subject too close to the background? Should the background be thrown out of focus by using shorter depth of field? Should the subject smile? Is the camera focusing correctly? It looks like the subject is losing interest. What can I say to engage her? Is her necklace straight? What can I do to have the photo "tell a story"? How about shooting at a different angle? Up? Down? She is wearing a white blouse with a dark skirt. Which should be metered?

There are countless factors, all vital, that have to be processed in split seconds when shooting. Knowing this, and being able to process it all on the spot, is what makes you worth what you are charging for your professional work.

Of course, that's just the start of the list. You must also know how to work well with your client. You must know presentation and sales techniques. You must understand finances. You must master editing software. Basically, being worth your fee means becoming a master of all aspects of the business.

All the necessary elements can be overwhelming at first. If you are just getting into the business, don't become discouraged. It will take time and effort on your part. Even if you're a long-time professional, there are probably areas of your business that you know in the back of your head could use improvement. Maybe you've neglected your marketing or not kept up on the latest developments in post-processing. It can be hard to keep pushing yourself year after year, but it's important to identify areas where you can improve and begin working on them.

BEING WORTH YOUR FEE MEANS BECOMING A MASTER OF ALL ASPECTS OF THE BUSINESS.

TIP #16

Build a resource library.

Books are practical and inexpensive resources for learning about lighting, posing, digital imaging techniques, the legal and business aspects of professional photography, and much more. They are also useful for getting into the heads of some of the world's most successful photographers—learning what they do that makes them unique. Additionally, they can be a source of creative inspiration. Seek out photography books showcasing work by the best photographers from decades past (Ansel Adams, Paul Strand, George Hurrell, and many others) right up to the many masters of today. Whatever genre you want to work in, there are books to inspire and inform you. (If money is an issue, consider buying used or checking out the offerings at your local library.) What other medium can be so easily notated and highlighted for future reference?

Amherst Media, the publisher of this book, offers countless instructional books for photographers of all skill levels. Their impressive list of titles includes books on portrait and wedding photography, lighting, nature photography, sports and event photography, legal issues, and even an illustrated dictionary for photographers. Visit their web site at www.amherstmedia.com for more information.

TIP #17

Learn more about photography online.

Blogs, forums, and web sites offer a constant flow of advice, education, and inspiration, often at no charge. Online forums and blogs are are updated regularly and are a great way to get up-to-the-moment reviews on equipment and techniques. You can also use them to network with other photographers.

There are hundreds and hundreds of online resources for learning about every aspect of professional photography. Some are fee-based classes in which you work directly with a professional photographer who provides valuable feedback via the Internet. Others are free tutorials, either text or video based, that allow you to follow along at your own pace. Several helpful instructional sites are listed below.

BLOGS, FORUMS, AND WEB SITES OFFER A CONSTANT FLOW OF ADVICE AND EDUCATION, OFTEN AT NO CHARGE.

www.apogeephoto.com
Free online workshops and "tripods on the ground" photography-based tours.

www.digitalweddingforum.com
Lots of information on the latest equipment, products, and techniques for wedding photographers.

www.illustratedphotography.com
Check out news, tips, tutorials, contests—even buy or sell equipment. You'll also find a community of "camera huggers."

www.Lynda.com
A fee-based resource with thousands of tutorials on a variety of subjects.

www.photosecrets.com
Free online tips on three levels: beginner, intermediate, and advanced.

www.photoworkshop.com
Educational info on this site is offered at different fee levels, beginning with free.

www.pro4um.com
A subscription site for professional photographers.

www.prophotoresource.com
A wide variety of materials on posing, lighting, and just about everything you can imagine.

www.shootsmarter.com
Features free and low-cost "smarticles" submitted by professionals.

www.spartists.com
A blog site devoted to senior portrait photography.

www.strobist.com
A popular blog site filled with great information on lighting.

www.theonlinephotographer.com
This site claims to offer "everything of interest to photographers," including photography news, industry notes and critiques, book reviews, equipment reviews, and more.

TIP #18

Photography conventions are well worth the investment.

NATIONAL PHOTOGRAPHIC CONVENTIONS WELCOME THOUSANDS OF PHOTOGRAPHERS EACH YEAR.

National photographic conventions welcome thousands of photographers to a single convention each year. New York's PhotoPlus International convention is the largest one of its kind in the United States, welcoming over 30,000 attendees. Excellent speakers touch on all aspects of the business. It's worth every penny of the investment to attend at least one each year to catch up on advancements in the industry and invigorate the sleeping artist within you. Three major national conventions to consider are:

Professional Photographers of America (PPA)
www.ppa.com
The Imaging USA annual convention takes place annually, early in the year. Locations vary.

Wedding and Portrait Photographers International (WPPI)

www.wppionline.com

WPPI's annual convention is held each year in Las Vegas, usually during the first quarter.

PhotoPlus International Photography and Design Conference + Expo

www.photoplusexpo.com

PhotoPlus is held in New York City every October.

Smaller conventions are also presented frequently by state and regional PPA affiliates. These are an excellent resource for education, and registration fees are usually lower than for national venues. Additionally, some conventions specialize in children, seniors, school photography, lighting, etc. These allow you to socialize, network, and learn from others who share the same specialty. It can also be a great way to learn about an area of photography you're considering adding to your repertoire. Children and Family Photographers of America (CFPA) (www.cfpamerica.com), Digital Wedding Forum (www.digitalweddingforum.com), and Photoshop World (www.photoshopworld.com) all host specialized conventions.

TIP #19

Buying does not equal learning.

Be cautious about letting the ever-pesky "spending bug" bite you on your trip to photography conventions or seminars. Many presenters also share their expertise in the form of books, DVDs, and CDs. Convention-only discounts can make these alluring—and these educational materials *are* valid and useful—but make sure not to invest in more materials than you actually have time to open and study when you get back to your "other life." (Knowledge from instructional materials does not automatically enter your brain when the cash needed to buy them flows out of your pocket!)

BE CAUTIOUS ABOUT LETTING THE EVER-PESKY "SPENDING BUG" BITE YOU ON YOUR TRIP TO PHOTOGRAPHY CONVENTIONS OR SEMINARS.

TIP #20

Keep your head about you at the trade show.

Additionally, the alluring trade show at a photographic convention beckons between presentations by speakers. Willy Wonka's fictitious candy factory is nothing compared to the lusciously luminous array of gizmos, gadgets, and goodies you'll find—again, at convention-only prices. If you know ahead of time what you need (and that's *need*, not want), you will most likely save big bucks. Many dealers will even absorb taxes and ship-

Photographic magazines are inexpensive, up-to-date resources that educate and inspire.

ping as part of their enticing convention special. On the other hand, if you allow yourself to indulge your every wish and overspend, you'll come home to a big credit-card bill—and perhaps a healthy dose of buyer's remorse.

TIP #21

Industry magazines keep you current.

Magazines are up-to-date resources for inspiration and continuing education. Some trade subscriptions are offered free to qualifying professional photographers. Check each publication's web site for subscription details.

AfterCapture (www.aftercapture.com)
This magazine deals with post-processing and is the sister publication of *Rangefinder*. Qualified photo pros can subscribe for free.

Apogee (www.apogeephoto.com)
A free online photography magazine containing tips, guides, books, and links to over thirty online photography magazines.

Bella (www.cfpamerica.com)
An online magazine dedicated to family and child photography.

Double Exposure (www.doubleexposure.com)
A well-rounded online magazine with lots of class. Includes historical articles as well as timely information.

Online Photography (www.onlinephotography.com)
This journal of fine-art photography also offers helpful links to photography sites and photographic information.

PC Photo (www.pcphotomag.com)
This magazine features plenty of helpful tips and a useful help line.

Photo District News (www.pdnonline.com)
Referred to as "PDN" by those in the industry, this magazine is always on the cutting edge. If you're in advertising, fashion, or editorial photography, you should definitely read this magazine.

Photoshop User (www.photoshopuser.com)
Receive this informative how-to magazine as part of your membership with National Association of Photoshop Professionals.

Popular Photography (www.popphoto.com)

This publication claims to be the world's largest imaging magazine. The magazine includes tips and tricks for intermediate-level professionals as well as recreational/hobbyist photographers. Nevertheless, there may be something for everyone to glean from this publication.

Professional Photographer (www.ppmag.com)

This top-notch professional magazine, published by Professional Photographers of America (PPA), showcases the crème de la crème of photographic excellence. Go to their web site to subscribe.

Punto Magazine (www.puntomagazine.com)

An informative magazine with the Hispanic community as its focus. Most articles are written in both Spanish and English.

Rangefinder (www.rangefindermag.com)

One of the leading photography magazines targeted for professional photographers. Free subscriptions are offered to qualified professionals. Every professional should read the information presented in this publication. Order a subscription from their web site.

Sight Fine Photography (www.sightphoto.com)

Provides an in-depth look at art and commercial work.

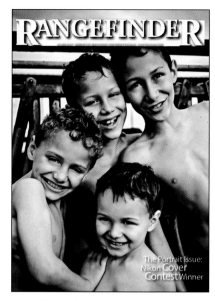

Rangefinder is a leading industry magazine that offers up-to-date technical articles, interviews, reviews, and more. Cover photo by Breanna Schapp.

TIP #22

Find a mentor.

Having a good mentor—an established photographer who guides your professional development—can be an invaluable experience for new photographers. Though successful photographers are very busy, they are notoriously generous with their knowledge, and most recognize the value of mentoring a newcomer to the field.

California photographer Tony Corbell says, "New photographers need to consider the importance of spending time with other photographers. Nothing can jump start your career faster than knowing the hurdles that others in your area had to jump over to get established."

If you are just starting out and want to reap the benefits of working under a mentor, be sure that you are bringing valuable skills to the table and have something to offer. Don't go knocking on a busy professional's door, expecting him to teach you all the basics. Obtain your knowledge,

get lots of experience, and then prove you are worth his or her time. Volunteer to be an apprentice.

TIP #23

Get advice from the store where you purchase your equipment.

The Internet makes it easy to buy products, but the service and advice that accompany those purchases can be negligible. Check out your local camera stores; there's nothing like old-fashioned, hometown service (and you'll probably meet some people who love photography as much as you do). Giant photography mega-stores from the East Coast to West (e.g., Unique Photo in New Jersey and Samy's Camera in California) offer equipment as well as advice. Some locations also teach classes on a variety of topics, such as lighting, composition, camera basics, and metering.

TIP #24

Join local professional photographers' groups.

Professional Photographers of America have local guilds in most major metropolitan areas. Find out where they meet and join their ranks. Most of these groups offer both networking and educational services, often bringing in lecturers to speak at their meetings. You may also be able to have your images evaluated by your peers. This is a good way to hone your skills and achieve recognition in your own backyard.

TIP #25

Test your mettle in photography contests.

A GOOD WAY TO LEARN THE "RIGHT STUFF" FOR EXCELLENCE IN PROFESSIONAL PHOTOGRAPHY IS TO EXPERIENCE THE JUDGING PROCESS.

Photography contests pop up here and there. Many require entry fees or some type of membership in order to participate. Look through online photography magazines to find contests. Try www.illustratedphotography.com for their *free* contest; there are no prizes, but there are no entry fees either. You can also use an Internet search engine to look for updates on contests sponsored by Adobe, Fuji, Nikon, F. J. Westcott Lighting, photo labs, and magazines. Press yourself into excellence through competition with your peers *and* yourself. It will get your creative juices flowing.

TIP #26

Attend or enter national print competitions.

A good way to learn the "right stuff" for excellence in professional photography is to experience the judging process at a national convention's print competition. Prior to the WPPI convention, for example, specific rooms are dedicated to judging competition prints submitted from around

These images were taken as part of a photo assignment in a lighting class taught by Carl Caylor at Image Explorations, located at the edge of Lake Shawnigan, Vancouver Island, British Columbia. Photos by the author.

the globe. Review the portraits, weddings, seniors, etc., to see what category fits you best and what other professionals in your chosen field are doing. To enter a print competition, you must learn the highly specialized process. It's a costly, time-consuming endeavor that requires working your way up to a "qualifying" position—something like an Olympic athlete. Entry requirements are posted on www.ppa.org and www.wppionline.com.

TIP #27

Photography safaris and short-term photo schools serve as vacations.

Extended workshops, usually lasting several days and taking place in a scenic location, are educational and offer lots of friendship and fun along the way. Most offer a classroom component with plenty of personal attention and time to ask questions. This is often paired with group shooting expeditions or sessions with test subjects, letting you put into practice what you learned in class. Some schools offer on-site or nearby food and lodging for a low additional fee (and the food is usually outstanding!). Dormitory-style lodgings may be available. Who cares about the room? It's convenient, and the sheer mental fatigue will knock you out cold at day's end.

The list below provides a partial glimpse of available short-term (three to five days) "destination vacation" workshops. Generally speaking, workshops in the "under $1,000" category will accept more students and provide more of a classroom setting (with lab), and usually three meals per day. Check *Apogee Photo* (www.apogeephoto.com) for an extensive list.

$ = under $1,000
$$ = under $2,000
$$$ = $3,000 and up

Adventure Photo Expeditions ($–$$$)

www.adventurephotoexpeditions.com
Offers photography expeditions in the United States and abroad.

California Photographic Workshops ($)

www.cpwschool.com
Located in Mission Springs, CA (near San Francisco), a landscape of towering coastal redwoods and shady oaks is the setting for these one- to six-day workshops taught by an excellent selection of accomplished photographers and artists.

Mummy caves is one of the dramatic and varied photo venues arranged by Carmen Hunter, local photographer and Native guide who works with Facerock Productions. See page 30 for additional information.

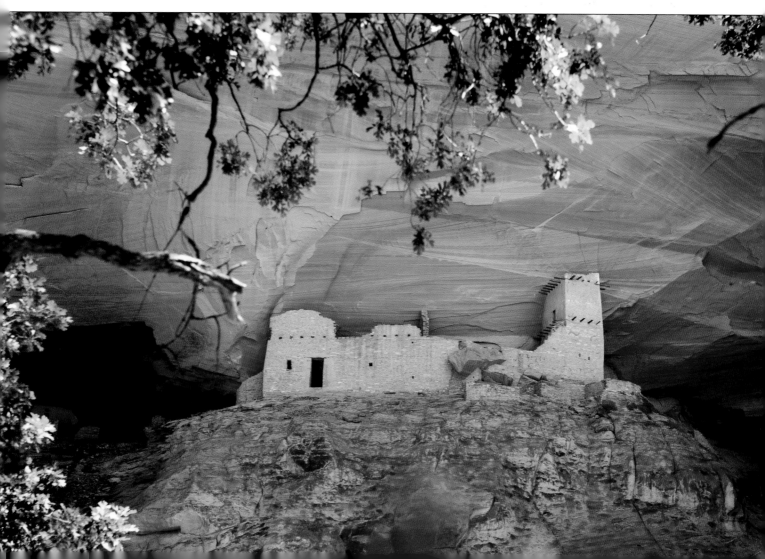

This fashion shoot was just one of the diverse opportunities presented by Facerock Productions during the photo safari to Canyon de Chelly in the Navajo Nation of Arizona.

Exposure 36 Workshops ($)

www.exposure36.com

Offers various photography expeditions across the U.S.

Facerock Productions ($$)

www.facerockproductions.com

These Arizona workshops are led by David Davis (PPA Master Photographer) and Carmen Hunter, a Navajo guide who lives in the beautiful Canyon de Chelly area of Arizona. Carmen is a photographer whose roots there stretch back to an ancient era of enchanting petraglyphs and legends. She is well connected with her extended family and is happy to introduce visitors to their traditional ways of sheepherding, weaving, and other long-practiced customs and rustic ways of living.

First Light Tours ($$–$$$)

www.firstlighttours.com

Offers international photography expeditions.

Golden Gate School of Photography ($)

www.goldengateschool.com

Offers extended workshops on a wide variety of topics for established and aspiring photographers. Classes and dormitory-style room and board takes place on a beautifully landscaped historic college campus in Oakland, CA.

Horizon Workshops ($–$$$)

www.horizonworkshops.com

Offers a variety of international photography expeditions.

Image Explorations ($)

www.imageexplorations.ca

A PPA-affiliate school located in an enchanted locale beside a lake on beautiful Vancouver, British Columbia. The instructors are excellent, and so is the food! Dormitory accommodations are available at a reasonable fee.

Mentor Series ($–$$$)

www.mentorseries.com

These worldwide photo treks may not be the most budget friendly, but traveling to exotic spots with nationally established photographers is an incredible opportunity.

National Geographic Expeditions ($$$)

www.nationalgeographicexpeditions.com

National Geographic lives up to their reputation for providing a taste of exotic and colorful destinations that will provide travelers with a wealth of flora and fauna to be photographed and enjoyed for years to come.

WORLDWIDE PHOTO TREKS MAY NOT BE THE MOST BUDGET FRIENDLY, BUT ARE AN INCREDIBLE OPPORTUNITY.

PPA-Affiliated Workshops ($)

www.ppa.org

Professional Photographers of America affiliate groups offer extended workshops, or "schools," in various locations in the United States and Canada. Their web site offers a complete list of workshops.

Santa Fe Workshops ($)

www.santafeworkshops.com

An acclaimed workshop series based in Santa Fe, NM.

Small, Independent Workshops ($$)

Smaller, more intimate workshops are offered by individual photographers such as Drake Busath and Kevin Kubota. (See page 123 for web addresses for these workshops.) Destinations have included Italy, Hawaii, and other dreamy places that beckon sweetly to you and your camera.

Texas School ($)

www.tppa.org

A five-day, PPA-affiliate school with intense photographic instruction and fun. The added bonus of social events and great food is always a strong incentive.

TIP #28

Don't jump without a parachute.

Transitioning from a reliable weekly paycheck and benefits (health insurance, a 401K, paid sick days, etc.) to an unknown income is scary. If you are a new pro, don't rush headlong into your business until you have a solid business plan and know that you have done everything in your power to ensure your success. Keep in mind that many photographers start out working part time.

To learn the key elements necessary to develop a business plan, attend national photography conventions. The importance of attending these events can't be stressed enough. This is where you will learn what the industry is all about and be able to access current information all in one place! Compare your own skills with those of professionals who are top performers in their craft.

TIP #29

Join a professional photographic organization.

Professional Photographers of America (PPA) and Wedding and Portrait Photographers International (WPPI) are two examples of industry-focused organizations that support professional photographers. PPA has a members-only download section on their web site where a number of documents can be accessed to help start and run a photography business. Check out "Starting a Business" as well as the "Studio Financial Benchmark Survey Analysis." Scott Kurkian, CFO of PPA, says, "Not everyone has what it takes to be an entrepreneur. PPA has created financial tools and training for this industry that has never been available elsewhere. Every PPA member should take advantage of them to increase the likelihood of being successful, financially."

PPA, a nonprofit organization, offers professional photographers copyright support, insurance, and workshops in business basics and studio management. Their magazine, *Professional Photographer,* features monthly money-saving and profit-oriented tips in their "Profit Center" section, which you can read online or in the print version of the magazine.

TO LEARN THE KEY ELEMENTS NECESSARY TO DEVELOP A BUSINESS PLAN, ATTEND NATIONAL PHOTOGRAPHY CONVENTIONS.

Create a business plan.

"Whether you're selling pencils, ball bearings, or photography, the elements of a business plan are essentially the same," says Ann Monteith, Master Photographer and business advisor for the photography industry. Sample business plans can be found on the Internet or at the library. (*Tip:* Download "The Profit Center," Ann Monteith's monthly *Professional Photographer* article from her web site: www.annmonteith.com.)

EVERYTHING ABOUT YOUR BUSINESS SHOULD SPEAK TO YOUR DESIRED CLIENT DEMOGRAPHIC.

Basically, the purpose of a business plan is to provide structure for your business. Such a plan should address several issues, including your mission statement, goals, and objectives for the studio; the type of photography provided, target audience, and client share for your studio/community; marketing strategies, projected growth, keys to success, and more. Google "business plans" for more enlightenment from web sites, including www.bplans.com. This site offers a sample phtography business plan and affordable software to help you create it.

"Having a business plan is crucial, even if your business is part time," says Al Hopper, Director of PPA Membership, Copyright, and Government Affairs. If you don't like the business end of running a photography studio, you need to have the financial resources to hire someone who does.

Tip: Use managerial accounting standards endorsed and outlined for you by PPA to track your business progress.

Develop your brand.

The buzz word in today's marketing world is "branding." Everything about your business should speak to your desired client demographic. For instance, if you want to spend your time creating cutting-edge images, you'll want to ensure that you are sending that message to your clients. You'll probably want to choose clean, bold advertising, a strong logo, and a punchy color scheme when designing your marketing materials. Your studio should be decorated in a way that reinforces this message too. Think about all of the marketing materials and other visual elements of your business that your existing and prospective clients take in. Is the style, mood, and message consistent? Does everything appear to originate from the same source (your studio)? Develop a color scheme and syle that suits your business, and make certain that "branding" targets the population you are reaching out to.

Once you've established your "brand," be sure to keep exposing your prospective clients to it. Try not to give into the temptation to change any

element of your "look" too quickly or too often. In a *Professional Photographer Magazine* article by Jeff Kent (Oct. 2007, p. 72), pro photographer Stephanie Clark sounds off on the topic: "It drives me crazy to see photographers who change their logo once a month," she says. "Decide on something and stick with it!"

TIP #32

Know your cost of goods.

"One of the most important factors to consider," urges Scott Kurkian, CFO of PPA, "is the cost of goods sold." In other words, you must figure out what it costs to send each photograph out the door with a client. This includes the dollar amount you pay yourself for the time it takes to produce each image. If this is not figured into your business plan, Scott says, "It's like creating a portrait of a person and cutting off the head."

PPA's 2005 survey of photography businesses provides alarming statistics for home- and studio-based pros. Percentage of gross sales ran at 25 percent and 19.3 percent, respectively. Nevertheless, the top-performing studios exceeded the benchmarks and did very well, financially, achieving 40.7 percent of gross sales. The bottom line determined that retail studio owners' prices were not high enough to compensate for general expenses. Remember, profits are monies kept once all of your financial obligations are met. Keep a close eye on your pricing and your budget (including everything from advertising to employees to maintenance, supplies, and taxes) to keep your business afloat.

EXPERTS AGREE THAT $100,000 IS REQUIRED BEFORE HIRING A FULL-TIME EMPLOYEE.

TIP #33

Raise prices instead of lowering them.

I sell wall art through a gallery in Scottsdale, AZ. I found it surprising (but heartening) to learn that when a piece of my art wasn't moving off the wall, the owner of the gallery raised the price instead of lowering it! It worked—the piece sold shortly after a higher price tag was attached. Generate respect for your work through price.

TIP #34

Put off hiring until you can afford it.

Don't hire employees until your business generates enough money to cover the expense. Experts agree that $100,000 is required before hiring a full-time employee. Until you can afford to hire a staff, outsource as much work as you can.

TIP #35

Sign on an intern or mentor an assistant photographer.

Colleges often require students to get hands-on experience in their chosen field. Contact instructors to let them know you are interested in mentoring a student. Put your contact information on college bulletin boards or check with the career center. Interview at least three candidates. However, take note of this important caveat: interns require a lot of time and attention. Structured teaching sessions must be planned to ensure that neither one of you waste the other's time. Start out with simple tasks that don't require a huge learning curve, and keep in mind there is a good chance the student will vanish at the end of the semester.

TIP #36

Trade for services.

Need a sofa reupholstered for your showroom? It's likely that the upholstery specialist would like photographs that show his expert workmanship. Need a logo designed? Ask a graphic artist to trade her services in exchange for family portraits! Note that such trades work best when little expense for product or materials is involved. Check with your CPA on this one.

TIP #37

Secure your capital reserves.

"Many photographers fail because they don't have enough capital to make it through the hard times. It takes a while before you can generate money," says Scott Kurkian, PPA's CFO and studio management services director.

Budget your capital investments carefully, and guard your cash. Avoid managing your business according to the balance in your checkbook.

CONTACT INSTRUCTORS TO LET THEM KNOW YOU ARE INTERESTED IN MENTORING A STUDENT.

TIP #38

Equipment may not be your most important investment.

Someone once said, "It appears some beginning photographers continue to buy new equipment, backgrounds, and doodads instead of photographing clients. Could this be 'photo phobia'—where 'building up the arsenal' provides a form of comfort and feeling of progress, thus squelching the angst of reaching out to find new customers?"

I asked twenty-five established photographers the question, "After the purchase of a good camera and lens, what would you recommend as the next three investments for someone beginning in the photography business?" Their answers were all over the map, as each reflected back to their beginnings, but marketing and imaging software were high on the list.

Facing page—*Chastity Abbott is a great example of a photographer who can capture highly professional photographs using basic equipment. As a young mother, she has tempered her spending on photographic equipment. Her web site, www.storybookmoments photography.com, shows her talent for getting the most out of an image with a Canon Rebel XT and then tweaking it with inexpensive software (try Adobe Photoshop Elements or Photo Explosion Deluxe by Nova Development).*

In the fashion world, "accessorizing" means adding embellishments that make you look better. It's not all that different in photography. Kidding aside, photographic accessories can be categorized in two ways: needs and wants. Be honest when asking yourself if you really need a new piece of equipment. You don't need every new photo accessory that becomes available or tickles your fancy. That said, continue to modestly upgrade your equipment as finances allow in order to establish as "aura" of the consummate professional that you are.

TIP #39

Consider renting equipment.

Tony Corbell once said, "As far as equipment goes, all you need is a roll of duct tape . . . all the rest can be rented." Though the statement is comical (with duct tape now replaced with A-clamps), it's sage advice from an ultra-professional photographer who knows the business inside and out. Renting is a fairly inexpensive alternative to purchasing and, more importantly, it gives you the opportunity to try things out or simply use the equipment for a special assignment. Large retailers have rental programs; inquire about rentals at your local camera stores too.

An SB-800 or 900 flash unit is a great item to rent because it puts out a powerful source of light and can be used remotely (without an additional sensor) to create artificial lighting where needed, whether in a studio or elsewhere. Rental will run about $10 to $15. A Nikon D200 digital body might go for $100 a day, but the later model D300 will cost almost twice as much. Don't forget the lens to go with it! They run about $35 each. Leasing contracts for camera equipment is a more long-term option and requires a commitment of $1,000 to $150,000.

TIP #40

Triage your equipment shopping list.

In times of war or civil disaster, critical prioritization of patients for medical treatment is conducted. "Triaging" involves consideration given for the seriousness of the injury. The same process should be used to acquire the items on your equipment list. Your "need" will depend on your photographic specialty.

TIP #41

When you get new equipment, thoroughly learn to use it.

When you buy a new camera, do you instantly take it out for a thorough test drive, or are you the type who puts it aside and has to get up the

Left—This image shows two great finds. On the left, a wallet from the dollar store. The chain alone is worth the investment to keep compact flash cards on a tight leash. On the right, we have a hotel promotion give-away was designed for credit cards but is perfect for flash cards, a little cash, and free lens cleaners. *Center*—This very sturdy yet lightweight backpack was purchased at a big box store for $15. Two deep compartments (lined with two inches of foam) are great for lenses and camera body. Additional compartments are roomy enough for ExpoDisc, water bottle, filters, etc. Another plus: to a thief, it doesn't look like it's full of expensive camera equipment. Use at your own risk, and always cushion with foam! *Right*—A small kit filled with some handy tools can help save the day when shooting on location.

courage before confronting it? Many professionals use their camera in the program mode, because that setting on a high-end dSLR does a very good job. That said, they know when to use the aperture priority setting, or how to set the camera to manual mode when needed.

One of the best ways to get on top of the learning curve is to take a class that offers practical experience. Many large camera stores offer these classes. Alternatively, you can set up "self-assignments" that will provide a thorough "drill" through the features of your camera. Experiment with photographing a still-life subject using different apertures, shutter speeds, and shooting modes. Test the camera's white balance presets, and purposefully choose the "wrong" color settings to see, for creative effect, what the resulting images look like. Pretend you will be giving a class on using this camera and must explain all its features to your students. This will help you learn all the features and capabilities.

TIP #42

Save money on small purchases.

Small photo accessories add up fast. Look for inexpensive substitutes. As your business grows, it may be hard to part with those initial, temporary solutions!

TIP #43

Assemble a small "tool" kit to accompany your camera gear.

Find a small, zippered pouch to stock with a few handy tools that can help save the shoot when working on location. Useful items include mini A-clamps (available at home improvement stores), a marker, super glue, small screwdrivers, a pocket knife, and a few feet of duct tape wrapped around a small tube (a lipstick cap works for this).

Less expensive imaging software is available.

Imaging software can set you apart from all those folks who carry around just as many megapixels. The most commonly used professional program for image processing and workflow is Adobe Photoshop with Adobe Bridge or Adobe Photoshop Lightroom.

Another powerful photo manipulation program, Capture NX, is available at a fraction of the cost of Photoshop and even comes free with some Nikon products (note that it is not exclusively for Nikon shooters). Use Capture NX to correct selected portions of RAW image files that are too dark or too light.

Don't waste time fixing poor captures.

Yes, mistakes happen, but it is essential that you learn to achieve correct lighting during original capture. Photographer Tim Walden was quoted in *Professional Photographer Magazine* as saying, "A photographer will never reach his or her potential by simply illuminating the subject and expecting to create the image post-capture, not without creating direction and flow with the lighting. When you do, you'll excite the viewer."

During a location photo session, the client suggested putting everyone on a porch bench in the late-afternoon sun. Though the photographer knew the lighting wouldn't provide a good outcome, the closeness of the family was appealing. In just a few minutes, the image was turned into a watercolor in Photoshop. Photo by the author.

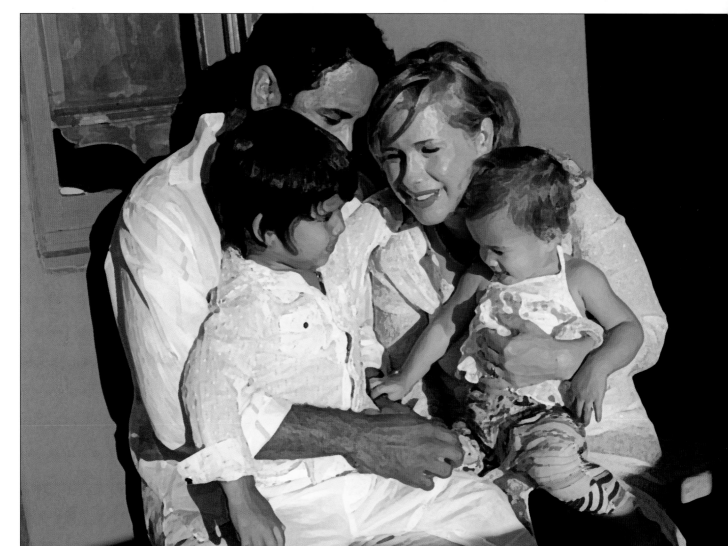

The digital fix that resulted in the final image (left) of this pose was not so simple. None of the captures (see the small images) showed good head positions on all of the subjects, thus requiring the combining of elements from both images. Photos by the author.

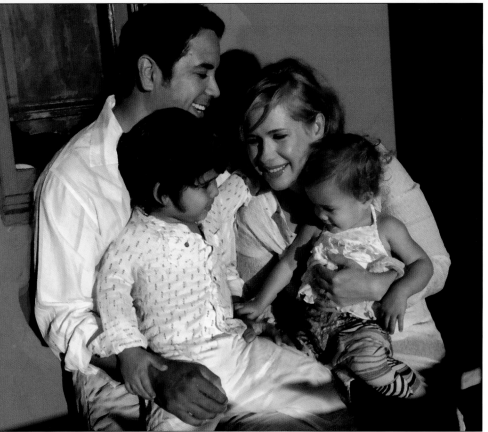

Correcting issues in Photoshop that could have been prevented in capture is not only a waste of time; some also feel that the digital overhaul can hamper the image. Lighting guru Ed Pierce made this sentiment plain in a *Professional Photographer* article he authored (Oct. 2007, p. 54). He said, "With post-capture digital imaging techniques, everyone's images are looking the same, especially to the untrained eye. The way photographers will differentiate themselves from the competition in the future will be through pre-capture techniques more than post-capture manipulation."

TIP #46

Use plug-ins to save time—and images.

Newcomers to the world of professional photography are bound to make mistakes that come from (1) lack of knowledge about their camera, (2) miscalculation of lighting, and (3) from the bad habit of depending on

Underexposed image of a baby was converted to unique photo art, using Nik Software Inc.'s filters. The mother purchased this image along with others in the "art" series. Photos by the author.

what they see on the back of the camera. Many miscalculations can be remedied with software, especially if images are captured in RAW. Turn unusable trash to treasure with imaging software.

Adobe Photoshop Lightroom is a great asset that can help you streamline your digital imaging workflow. Lightroom's presets will help you save time. It's a must for any busy digital photographer.

TIP #47

Don't steal software (but don't pay full price either).

Top-of-the-line image editing software is expensive. However, here are some money-saving tips:

- Enrollment in community classes often qualifies you for generous software discounts that can result in savings of 80 percent. Purchase software through an online software outlet like www.campustech.com or another site approved by your school.
- Download software free for thirty days to see if the program you are considering performs the way you anticipate. Be aware that saving the edited images is not an option with some trial versions.

When given a choice of additional images that have a different look from others taken during the session, customers may purchase them with the intent of use in greeting cards, thank-you notes, or even high-end handbags. Photo by the author.

- Purchase Adobe Creative Suite (Photoshop, InDesign, Illustrator, Acrobat Professional, and Dreamweaver) at savings over individual product pricing.
- Purchase image editing software and actions at discounted prices at photo convention trade shows.
- Purchase Adobe Photoshop Elements, a "sister" program that provides some of the functionality of Photoshop at a fraction of the cost.
- Once you have Photoshop, search the Internet for demo samples of artistic plug-in filters or actions (from Nik Software, Inc. or Kubota Image Tools, for example).

TIP #48

Use actions or digital filters to lighten your workload.

Actions and digital filters can make image resizing, retouching, and en-
hancements easier! Actions are a series of digital commands that can help
you edit or produce creative enhancements in your images in record time.
Digital filters can be used to apply traditional photographic effects and
other exclusive-to-digital special effects at the click of a button.

TIP #49

Use image manipulation as a sales edge.

Actions and filters can help you create a more unique, artistically enhanced
image for your client with the push of a button. These programs allow you
to quickly crop images to create packages, convert color images to black
& white, create a soft-focus effect, vignettes, and much more.

*All three of these photos were taken during the same documentary session, but each was given a different look in post-pro-
cessing. General advice is to pick one "look" and stick with it for the entire series. The black & white image was created by going
through several steps in Photoshop only; the sepia images were created in one step using Nik Software Inc. filters. Photos by
the author.*

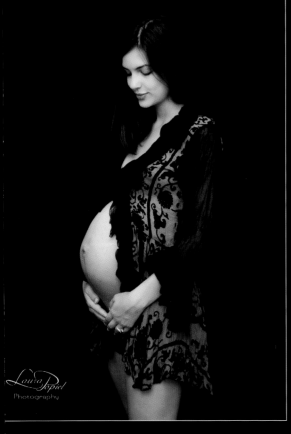

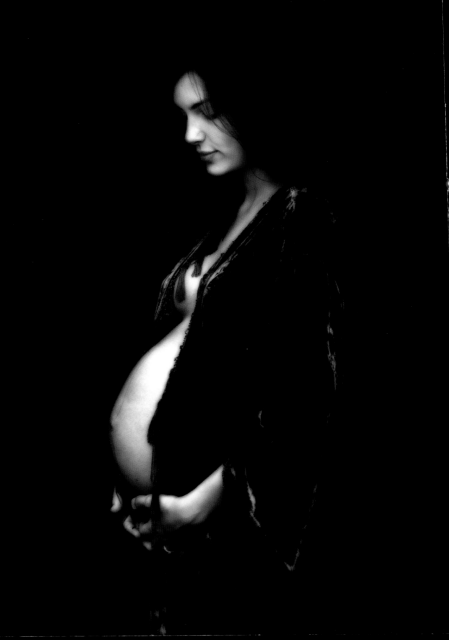

Facing page—(top left) The occasional extreme post-production treatment of an image can add pizazz to an album page, but take care not to overdo or overuse this "condiment" that adds spice to your work. Nik Software Inc.'s Old Photo filter added punch to this image. Photo by the author. (top right) Nik Software Inc.'s Vignette Blur was used to subtly enhance this image. Photo by the author. (bottom left and right) In the glamorous maternity images, Laura Popiel of Houston, TX, used Lord of the Rings (a Kubota Image Tools action) and Nik Software Inc's. Midnight Sepia filter to create two different looks from a single image. **Right**—Lisa Jane Murphy used LucisArt Software to add an old-fashioned lithographic look to a portrait of a boy in a tire swing.

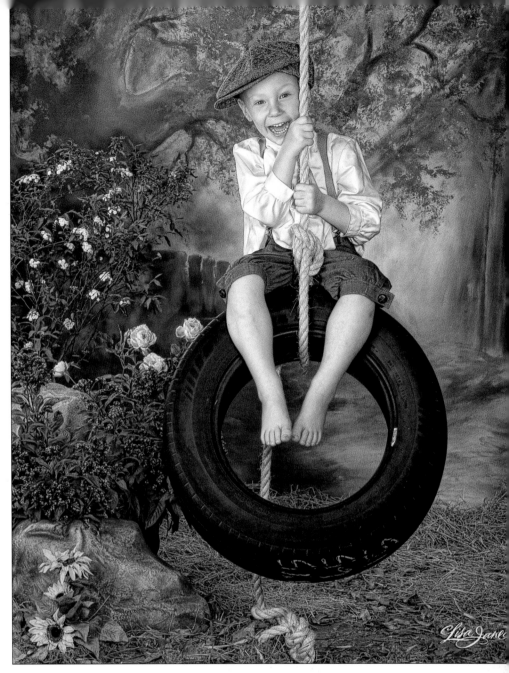

It's a good idea to spend some time getting to know your software. When you can predict the effects of using digital filters and actions, you can end the shot-in-the-dark trials that waste time (and money).

TIP #50

Create an "old fashioned" image in a flash.

Use Photoshop to create a vintage feel in your modern-day images. Simply go to Image>Adjustments>Hue/Saturation, then click the Colorize button. Manipulate the sliders to create a warm or cold-toned black & white image, or a sepia tone. Quicker and easier still, you can use one of the Nik Software Inc. filters or the Kubota ImageTools actions to create a old-time feel at the push of a button.

Paint in Photoshop (without additional software).

Photographers often purchase Corel Painter, using the program to create photos with a watercolor painted look. Kerri Kirshner of Bothell, WA, developed an easy watercolor process using only Photoshop. She used several different brushes and sizes to create a variety of textures. Leaving a few of the leaves and bark in an unpainted state maintained some of the original texture of the foliage and tree. Postcards featuring this image were made by a printing company that specializes in quality postcards for the photo industry.

Here are Kerri's step-by-step instructions for creating a painted image:

1. Open your original file.
2. Complete all needed retouching on its own layer.
3. Create a new layer and name it "painting."

Photoshop was the only program used to give this image an artful twist. Photos by the author.

Photoshop was the only program Kerri Kirshner used to create the painterly style seen in this image.

4. Choose a brush and start painting on the copied layer of the image. Adjust the opacity and flow of the brush according how you want the final image to look. Other standard brushes can be loaded into Photoshop (impressionist, leaf, oil sketch, etc.).

5. As you work, make notes about brushes, sizes, and opacities you've used.

6. Use a separate layer for each different brush or technique you use, and name the layer with the brush or effect name.

7. Add other elements, as desired, creating a layer for each new addition.

TIP #52

Graphics tablets and other hardware can be acquired for less.

Kerri's painted image (above) was created with a Wacom graphics tablet (www.wacom.com), which the company maintains is for the "serious photographer, designer, and artist." Savings are available through online catalogs of mega-warehouse stores. Keep your eyes open for sales and discounts on scanners, printers, and other big-ticket items. The bargains are out there.

NAME
Ciel Azul Carillo

DATE OF BIRTH		TIME OF BIRTH	
	April 9, 2007		8:08 am
WEIGHT		LENGTH	
	7 pounds		19.5 inches
PARENTS	Simone & David		
COMMENTS			
	Our cuddly little bundle... Our new baby girl has arrived!		

This image was captured after the actual photo session had finished. Beautiful north light falling on the infant, sleeping peacefully in the baby carrier on the client's dining room table, made for an irresistible photo opportunity. Of all the images from the session, the post-session image is what the mother selected for the birth announcement . . . a black & white rendering with just a hint of desaturated rosiness on the baby's lips and cheeks. Photos by the author.

TIP #53

Learn new imaging techniques with free tutorials.

Dave Montizambert offers free tutorials on his web site, www.montizambert.com. He has also produced Photoshop instruction CDs for Software Cinema (www.software-cinema.com), a reasonably priced "workshops-on-demand" resource for learning software.

TIP #54

Master natural light—it's free!

Free information about natural lighting is plentiful on the Internet. Much of the discussion, however, is related to creating a natural light look through use of artificial lighting. This technique may be essential in countries like Finland or Antarctica, where much of the year is spent in darkness, but for most parts of the world, natural light is the most affordable choice.

TIP #55

Don't purchase studio lighting without a hands-on trial period.

Newcomers to the photography business may not be able to afford the investment required for studio lighting. Also to be considered is whether the

photographer has actually settled on the type of photography for which he or she wants to be known. Options for artificial lighting are plentiful. Don't rush to buy until you have tried the lighting you are considering and are absolutely certain about what really fits your style and need.

A world of lighting is opened to you as you learn your craft. Professional photography conventions are excellent sources for enlightenment. Attend lectures and workshops where you will be exposed to innumerable photographers who use assorted types of lighting. Participate in workshops that provide opportunity for hands-on practice. Use different setups before settling on a lighting choice. Rent before you buy.

TIP #56

Inexpensive daylight-balanced bulbs are a great option.

Use artificial daylight bulbs for displaying and viewing images, and over your monitor or desk as well. Daylight-balanced bulbs can also be used as a hair light or background light. Consider lighting offered by Cooper Lighting or SoLux bulbs. Experiment with a daylight-balanced bulb inside a cone-shaped housing to illuminate the background or as a hair light.

TIP #57

Save time by mastering your camera's white balance settings.

Professional digital cameras feature white-balance presets (e.g., automatic white balance, daylight white balance, tungsten white balance, shade, white balance, etc.) that allow you to quickly neutralize color casts that can result when working in various lighting conditions. These settings can also be used to adjust color results. For instance, the camera's "shade" setting, when used in daylight, will render the image color warmer than it appears in the actual scene.

With a cone-shaped housing over a daylight balanced bulb, you can easily direct light onto your portrait subject's hair or onto the backdrop to create separation. Photo by the author.

Custom white balances can deliver more accurate results than the presets. To set a custom color balance, sample a white or gray card under the light where the image will be taken. The corrections needed to render the object neutral in color can be saved in the camera and used to ensure that there are no color casts the next time you shoot in the same conditions.

TIP #58

Use a gray card to ensure correct color rendition in your images.

White foamcore may be the cheapest white-balancing tool, but a correctly configured gray card is preferred. Fill the camera's viewfinder completely with the gray card and follow your camera's instructions for manually setting the white balance.

Lastolite's 20-inch pop-up EZ Balance is gray on one side and white on the other. This unit folds down to fit into a 9-inch circular case for easy transport.

TIP #59

Try a white-balancing lens accessory.

An over-the-lens white-balancing accessory that collects and averages light from the scene is a favorite tool of many photographers. There are several available; the ExpoDisc and ColorRight tools are industry favorites.

TIP #60

Use software as a backup for perfecting color.

So, you didn't get the color right in the camera? We image magicians have ways of reviving "dead" images. If you forgot to select the proper white-balance setting or simply didn't get accurate color, you can use Photoshop or Photoshop Lightroom. If you're not ready for these big-league programs, get your feet wet with Photoshop Elements, Capture NX, or Capture One to adjust color in post-capture; they are all affordable image correction tools. Photographing in the RAW file format makes correcting color easier.

TIP #61

Find lighting looks you enjoy, then learn to emulate them.

Study various photographic styles of lighting to determine how the photographer achieved it. Many of the pros are happy to talk about their favorite equipment and lighting setups. Claude Jodoin, for one, is a master of the one light setup. You can learn more about his expert techniques by

As you can see, colors are much truer after a quick white balance adjustment with an ExpoDisc. Photos by the author.

Left—*Pop-up flash produces flat, un-flattering lighting.* *Right*—*The subject was lit with a continuous light encased in an umbrella, resulting in a more dimensional, more professional look. Photos by the author.*

"The giant softbox became the preferred tool of family and senior photographers around the country. However, when my quest began, to make shifts in quality and style, I quickly realized that many of the photographers we idolize as the best of their time used smaller light sources and controlled much light. I came to the conclusion that there wasn't much control over the big white box, and the lighting was dull and flat, compared to the plentiful options available."

—Charles Maring (*Rangefinder*, Sept. 2007, p. 63)

purchasing one of his affordable DVDs, which are available on his web site.

TIP #62

Pop-up flash creates an amateur look in portraits.

The pros know that when catchlights appear in the center of the subject's eye, a pop-up flash was used to light the portrait. Though a studio lighting system is a sizable investment, you shouldn't use pop-up flash just to cut costs. This flat light will only create flat, unattractive, washed-out, unprofessional results. Consider using a reflector to bounce sunlight (indoors, use reflected window light) onto your subject to increase dimension and add polish.

TIP #63

External flash is an excellent first lighting investment.

Artificially created light can introduce drama in a photograph as well as give you better control. If you are on a limited budget, go for flexibility. Much is said about the Nikon external flash (Model SB-800 or 900 Speedlight). Its infrared capability enables it to fire remotely (i.e., when not mounted on, or otherwise connected to, the camera). This small, super-powerful unit can be used in conjunction with a small softbox for studio-like portrait applications, indoors or out.

You'll find a wealth of information on the topic of speedlights on the Strobist web site at www.strobist.com. Here's what they say about themselves: "This web site is about one thing: Learning how to use off-camera flash with your dSLR to take your photos to the next level. Here, you'll find everything you need to know about how to more effectively use your

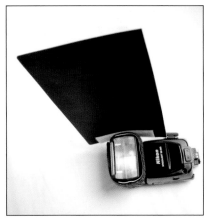

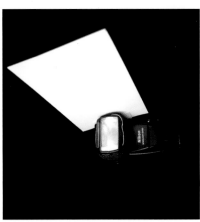

Top and bottom left—Remove the label (using a hair dryer) from an empty rubbing alcohol bottle and cut off the top just shy of fitting the head of the flash. Make small, vertical slits around the edge to hold the bottle tightly around the flash unit. Photos by the author. **Top and bottom right**—*This easy-to-make accessory will allow you to increase or decrease light when using your compact external flash. Photos by the author.*

small speedlights. There are more than 800 articles about lighting. Over a million photographers from around the world have learned small-flash lighting techniques from this site. We're thinking you can, too.

TIP #64

Make a light diffuser for less than $1!

Light modifiers for a speedlight can be made from Styrofoam cups or sundry pieces of translucent plastic, like a spent rubbing alcohol bottle.

TIP #65

Build your own external-flash shield.

This is an easy accessory to create for increasing, decreasing, or shielding light, where needed, using an external flash. The black side was created with a piece of black plastic, cut from a pocket-sized address book cover. The white side is a sheet of white write-on/wipe-off poster board (fasten together with double-sided tape). Find easy step-by-step instructions at www.strobist.com. Then again, why bother? David Honl has produced this Speed Gobo/Bounce Card. The strap and card can be purchased for about $20.

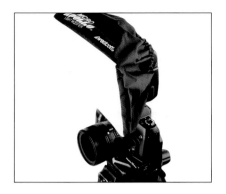

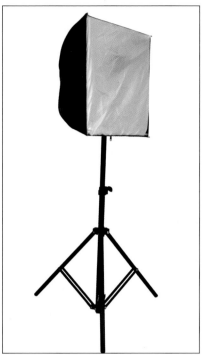

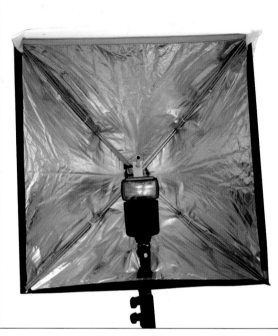

Left—F. J. Westcott carries a wide variety of lighting equipment and accessories, including the modestly-priced Micro- and Mini-Apollo light modifiers. Their Micro-Apollo attachment for external flashes eliminates red-eye and softens harsh light. It fits quickly and easily over any battery-powered strobe. Photo courtesy of F. J. Westcott. **Center***—F. J. Westcott's 16x16 softbox can be used inside or outside, because it is also used with a compact flash that can be fired remotely with the shutter release when the picture is taken. Photo courtesy of F. J. Westcott.* **Right***— Another economical reason to invest in a wireless-capable external flash is because it can be used with the nifty Speedlight kit Westcott has put together. This kit works in- or outdoors without the need to lug around a heavy battery. It's a practical item for any photographer, beginning or advanced, and comes complete with an 8-foot light stand, Micro Apollo, 16x16-inch Mini Apollo softbox, shoe-mount umbrella bracket, and L-shaped bracket. Photo courtesy of F. J. Westcott.*

"[Small flashes are] all you really need to take the plunge into high-end lighting techniques. Larger strobes have their place, but they tend to spend a lot of time in trunks and stuffed under beds."
—Strobist.blogspot.com

TIP #66

Invest in light modifiers. You'll never outgrow them.

A small shield or reflector of light that fits over an external flash and is a minimal investment with a big return. These smaller units will continue to serve you later on, as you work your way into larger softboxes, the standard of most professional studios. Portable light modifiers for speedlights are made by F. J. Westcott, Hughes Soft Light Reflector, and Gary Fong, to name a few. Check www.retrevo.com for comparisons.

TIP #67

The most clever light enhancer ever—for under $15!

Small softboxes are popular. They are easy to transport and set up just about anywhere additional light is needed. This light box (of sorts), assembled by Jon Haverstick (using directions found on Strobist) looks so

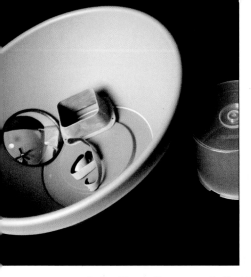
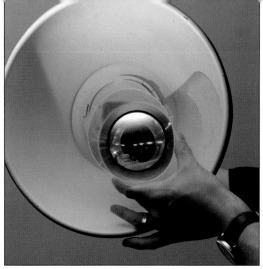
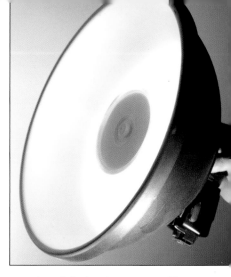

Left—Plastic flower pot shell with CD cover and an adapter piece, found in the rain gutter section of the hardware store. Photo by the author. *Center*—Convex automotive mirror on inside of CD cover (faces the flash when screwed in place). Photo by the author. *Right*—Nikon SB-800 flash firing from the rear. Photo by the author.

Left and center—Anything white or shiny works to put enhanced light on your subject. Car window sun-reflectors work well. Foamboard is inexpensive and readily available. Use white to add or "bounce" light and black to subtract or absorb it. White foam board can serve dual purpose as a projection screen. Hold a white translucent umbrella in front of a flash to diffuse light. Photos by the author. *Right*—Mirror-like insulation panels make great lightweight, free-standing reflectors, for under $10. Buy one panel and cut the shiny side only partway through, making one side slightly shorter than the other for differing reflection needs. For increased strength and durability, fold shiny foil tape (for use on flexible air ducts) around edges. Use reinforced carpet tape to add strength and "give" to the underside of the fold. Done! Photo by the author.

professional that even some pros would never know it wasn't one of the $500 versions. Believe it or not, it's constructed from a plastic flower pot! The rest of the "parts list" is composed of common items, readily available in DIY and office supply stores.

Find plastic flower pots in the garden section, advance to the gutter section of your local home improvement store, then move on to office and auto supply stores.

TIP #68

Use whatever is handy to add or subtract light.

Professional photographic reflectors and absorbers of light are a small expenditure and well worth it. Some versions of reflectors twist and fold into a smaller size for easy storage and transport. In the meantime, or if added "bounce" is needed, consider the options outlined in the following tips.

TIP #69

Build a small light tent.

A miniature light tent (a tent-shaped light modifier consisting of diffusion fabric stretched over a frame) makes the perfect environment for lighting small objects. When lights are placed outside of the tent, the soft, diffuse light inside the tent allows you to photograph the object without unwanted shadows and reflections.

"The way I use lights really depends on the story I'm trying to tell. I look at light as a language—each type of lighting says something different."
—Matthew Hummel (Linda L. May, *Rangefinder*, Sept. 2007, p. 8)

TIP #70

Create an inexpensive background light/hair light.

Use this idea with caution and experiment to test results in a portrait. Hang a cone-shaped housing that will accommodate a daylight balanced bulb. Experiment with colored background lights (or use gels over the standard bulbs).

TIP #71

Use a mirrored acrylic panel as a strong reflector.

Tony Corbell retrieved mirrored acrylic material from the discard bin at a DIY store. The use of the reflector in the image shown on page 56 added highlights to the model's dress and hair. Note that even in bright sunlight, reflected light can make all the difference in an image. Without the highlights, a beach portrait like this one could lack pizazz.

Jeremy Mager of Jeff Hawkins Photography, Orlando, FL, constructed the frame for this mini light tent from PVC tubing. Drape with translucent fabric (don't worry about any wrinkles) and light as shown, with regular studio lights or inexpensive shop lights. Photos by Jeff Hawkins Photography.

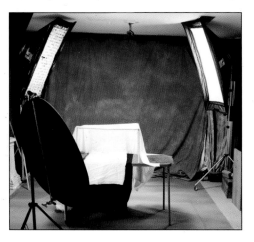

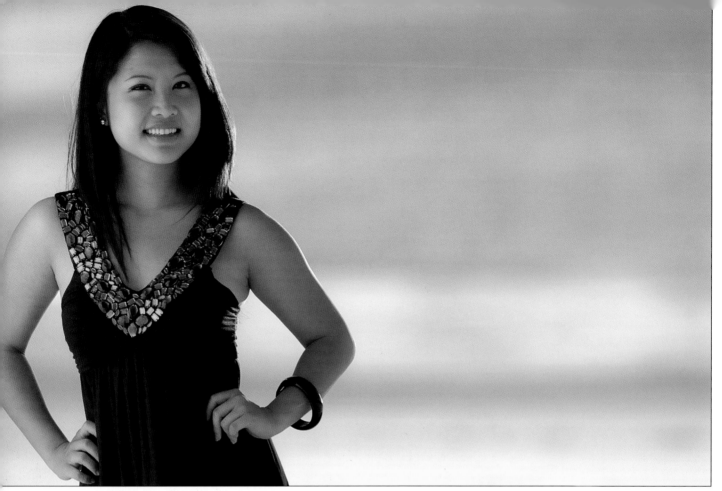

Corbell's mirrored acrylic panel added some rim light to the model's hair and highlights to her dress, making all the difference in the outcome of his photo session.

TIP #72

Try the freestanding "hunk" reflector.

Some photographers make their burly assistant wear a white t-shirt to a location shoot (or nab an appropriately dressed passer-by). After all, this type of a reflector has a stable, built-in stand and moves on its own without batteries (most of the time). White is white. Move him into just the

right position and tell him to "hold it." An occasional photographer will wear a t-shirt himself for bouncing light off his own body from an external flash.

TIP #73

"Paint" nonmoving subjects with a spotlight.

Italian photographer Emanuela Carratoni creates amazing Seventeeth Century Caravaggio-like masterpieces—with a flashlight! To create a similar look, first study the lighting effects the masters used when they painted still-life subjects. For the best results, look for foods, utensils, or other objects with a timeless quality. Next, follow the steps Emanuela uses to create her masterpieces:

- Select an 18–55mm lens
- Mount the camera on a tripod
- Set the shutter to the smallest aperture

Top left—A Brinkmann spotlight. *Top right*—A Brinkmann spotlight fitted with an F. J. Westcott Micro Apollo (see page 53). Photo by the author. *Bottom*—This still life photo was surprisingly easy to create. A Brinkmann halogen/L.E.D. rechargable spotlight was used to paint the subject with light while the exposure was made. (This light functions well for this purpose. It has a handle that is perpendicular to the light, and the light is activated by pressing a "trigger" on the handle. It can sometimes be found for less than $20 in the big box stores.) Note that a wide-open lens and a slow shutter speed are essential when using this technique. The crackle finish was created by merging the image with a crackle finish texture photo in Photoshop. Photo by the author.

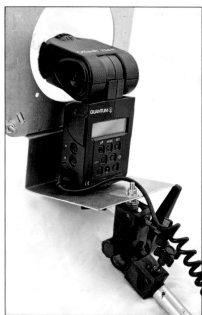

This ingenious adaptor allows you to use a studio softbox with a speedlight rather than a studio flash head. Photos by Jeff Hawkins Photography.

- Set the lowest ISO possible
- Set the shutter speed at 15 seconds
- Carefully place highlights and shadows with the flashlight

To see Emanuela's enthralling work, check out her web site, listed in the Other Notable Photographers section on page 117 of this book.

John Solano, an event photographer from Los Angeles, CA, uses the "flashlight gun" at weddings and other public gatherings and loves it so much that he is creating one of his own design—especially for photographers. Before the reception guests arrive, he puts the camera on a tripod and paints the wedding cake with light for dramatic results!

TIP #74

Nuts and bolts help create ingenious lighting solutions.

Jeremy Mager is a great assistant to have around the studio of Jeff and Kathleen Hawkins, located in Orlando, FL. Jeremy comes up with many practical lighting solutions. This solution pictured above was quickly devised and implemented using common items from home improvement stores.

TIP #75

Build a "take apart" scrim for studio and location work.

A scrim is a device placed in front of a light source to diffuse light and reduce its intensity. You can build this handy device quickly using fabric, PVC pipes, and a little glue (E6000). First, construct a large rectangular

or square frame out of PVC tubing and elbow connectors. The larger the frame, the stronger the PVC pipe should be. Next, glue or sew elastic onto the corners of the fabric you've selected. The fabric can then be attached to the frame by pulling the elastic over the corners of the frame.

A more durable solution can also be built. Choose fabric that is six inches wider and longer than the frame. Fold back the corners of the fabric and secure (glue or sew flat) or cut the corners off of the fabric. Next, fold over the four sides of the fabric to create three-inch pockets to hold the PVC pipes. Finally, sew the pockets, insert the pipes on each of the four edges, and attach the elbows. Done!

By changing the fabric, you can use the device for a background or reflector.

TIP #76

Use an affordable shop light as a studio light source.

Purchase one or two shop lights and stands from a DIY store. Use them behind a large scrim positioned above or to the side of the subject, or use them behind sheets hung from background stands.

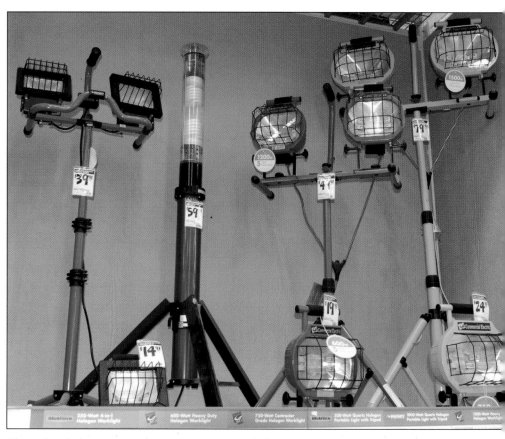

These shop lights are a ready-to-use, inexpensive lighting solution readily available at any hardware store. Photo by the author.

TIP #77

Take lighting workshops to save time and money.

Studio lighting is expensive. Also, a lot of space is required to set up studio lights (and the sqare footage required to house them can mean higher rent payments). Strobes and cold, continuous daylight-balanced bulbs are today's most popular options. Various lighting modifiers—from large and small softboxes, to umbrellas, to egg crates and many other devices—are used to soften the light, fill in shadows, and create direction. Depending on your session, you might need a background light, hair light, kicker light . . . the list goes on and on.

Before investing in equipment, attend several workshops hosted by photographers whose lighting you admire. By taking a hands-on approach you can determine just what feels right for your style and purpose. Many professionals start out big—accumulating all the latest and greatest light units and accessories—and then realize less is more.

TIP #78

Where studio lighting is concerned, compare apples to apples.

When budgeting for lighting, consider that some softboxes are sold without lights and others are sold with them. F. J. Westcott offers a money-saving package deal that includes a softbox; cold, continuous light; and stand. This can be a real benefit, since with continuous lighting, there is a shorter learning curve. Lights stay on throughout the entire session, making it easier to adjust the light intensity, see the effects, and meter. Also, portrait subjects who are sensitive to light will not be bothered by the flash.

TIP #79

Do you really need a light meter?

Some photographers swear by light meters and couldn't work without them. A budget-friendly suggestion is to get a good digital camera and let it do its job with figuring out the light until more funding is available for this expense. That's not to say that *you* don't need to know about f/stops, shutter speeds, and ISOs in order to achieve correct lighting.

Under most ordinary photographic circumstances, the camera will do a good job of metering, whether set on program, aperture priority, or shutter speed priority. The camera's spot metering option should be considered when the subject is set against a bright background. Practice evaluating light in various scenarios and calculate the required exposure settings. The practice will increase your odds of success when using manual settings to capture images with a non-average tonal distribution.

"Start with a softbox just out of view of the camera. When on location, a small softbox can be used with a speedlight inside. That maintains a nice shadow edge. Plain flash, even off-camera, can be very harsh."—Doug Box

This image was made for a portrait client who ruminates all year to come up with a concept for an original Christmas card. In 2007, her vision was to send out a glossy black card featuring bowls full of bright bulbs, the jovial message reading, "This Holiday Season [front] . . . Eat Light [inside]." A dSLR becomes very confused with an assignment like this, because it assumes that no one would want such a dark picture. With the camera on a tripod, the photographer set the camera to manual. She selected a slow shutter speed of $^1/_{15}$ and guessed at the aperture needed, choosing f/5.0. These settings worked with the first image, allowing the entire shoot to be completed in less than five minutes! Good thing, because the baby took the message literally. Photo by the author.

TIP #80

Marketing is an investment in success.

Before you can sell, you must market, market, market. Get the picture? Growing your business and attracting clients requires work. Much like a family, the long process needs constant nourishment of love and devotion with the occasional fine-tuning—not to mention a lot of discipline and money! Much free marketing advice can be found on the Internet. Marathon Press, McKenna Pro labs, and other companies provide marketing tips and webinars; some are free, and others are fee based.

TIP #81

Show only your best work.

Perfection may not be reached with every photograph you produce, but know what constitutes a quality photo, and show only your best work, even if you have to abandon images and re-shoot. If your work is not constantly excellent, don't book one-chance-only events, like weddings.

TIP #82

Be a card-carrying photographer.

You should always have business cards handy. Give them to all your relatives, friends, neighbors, and even to the occasional stranger. Strike up a conversation in the bank or supermarket (it helps if there is a darling little child standing in line with that stranger). Find a way to mention what you do, and hand them a card, providing them with some information about the goings on at your studio like, "Call me. I am having a really fun summer promotion in two weeks."

Business cards are a waste of money if the type and pictures are too small.

Your business cards are an important element in your marketing campaign. The front of the card should feature your logo and a sample photo or two. Your contact information (name, web address, e-mail address, and phone number) can be listed on the back of the card.

Too many business cards need to come with a magnifying glass! Script breaks down in printing and can become illegible, especially on black—so it's a good idea to have small, trial batches printed. You should use large, easy-to-read type (no scripts). You should also make sure that your images are "legible." You, as the photographer, may be able to vividly picture the beauty of your photo in its 20x24-inch glory, but the person receiving the card may hardly be able to make the subject out!

Keep your card looking clean, streamlined, and professional. Don't show a laundry list including everything you'll put in front of your lens.

Left—Font and photos are too small and illegible. Sample by the author. *Right*—Studio name and brand (logo) are easy to spot and "imbed" in the viewer's brain. Samples by the author.

Create specialized business cards.

Create a general card when you are starting out, but don't print 1,000s, simply because the rate is better on large quantities. See what works best, then move on to print cards directed to your special niche clients. For instance, in a friendly way, distribute maternity and child-themed business cards to the mother and child waiting in line next to you at the supermarket, exclaiming that you are so excited about your new business. Tell her, "Bring this card into the studio for a half-price session. Call me, I'll explain the details." (If you don't discount your session, use another incentive.) If you can't select just one image to feature on your card, have a small number (say, twenty cards) of a vairety of designs printed to test the market. Short runs are no longer an impractical expense (see tip #85).

TIP #85

Order small batches of business cards with different images.

Good news! Business cards can now be ordered in small batches of twenty for a nominal cost. One lab that provides this service is McKenna Pro (www.mckennapro.com). You can even use one of their free templates to design your own card and save money on artist fees. There are two big advantages to having small batches of cards printed, featuring different images, when you are starting out. First, your work will improve as you gain experience, and you don't want to be tied to an image that's inferior to your current work. Second, you can try out different ideas for your card to see what works best.

TIP #86

Print business cards after each session.

After each session, print a small batch of business cards featuring one of the photos from the client's session. Be sure to place your business name and contact information prominently. Customers will be delighted to pass them out to friends—especially if they get some kind of referral bonus for any new clients you gain as a result. If you like, discount promotions can also be added to these cards from time to time. Happy customers are your best advertising—and conservative advertising strategies such as this will help develop an ever-increasing flow of customers. Tack this minimal expense onto your print order (if your lab produces short-run cards) so it can be included with the minimum order charges.

TIP #87

Post a web site as soon as possible.

A web site is the only marketing tool some photographers use. When coupled with e-mail blasts, web site advertising can be very effective—and costs very little money. (Web sites from Bludomain start at $100.) On the other hand, if there is no web site, a photographer can lose potential customers. Free blogs from Wordpress can be used in lieu of a web site to test the waters for a part-time business. Alternatively, you can begin modestly by using a free template on a low-cost host site. As your business grows, demonstrate professionalism through your site. A web site is the first place most prospective clients go for more information about your business!

True story: A photographer was recommended to a bank manager who wanted Easter photos of her grandchildren. The manager, who was later asked how the session went, said, "I didn't call because she didn't have a web site."

Get on the blog bandwagon.

In-the-know photographers use their online social networking to keep their services on their clients' minds. Join sites like MySpace, Facebook, and Twitter. Blog about goings on, and let your clients know about your interesting new photo specials, assignments, and the like.

TIP #89

Postcard advertising pays off.

Postcards are readily available in standard sizes of 4x6 inches, 5x7 inches, and larger. Order through the Internet. Postcards are vastly more impressive to prospective clients than flimsy brochures that can easily be crumpled and tossed out. A stiff, shiny card with a captivating image is too beautiful to be thrown away. Use your most fascinating and alluring images to attract clients. Images that have "personality" or tell a story are great attention-getters.

Ana Brandt, who owns and operates Ana Brandt Photography, in Tustin, CA, started out with a postcard that worked well for her. Years later, she continues to consider them a useful marketing tool. She tells how her first card cost the business only pennies to produce. Her initial card (shown here) was a conventional size of 4x6 inches. She laughs as she remembers how she took a wrinkled white bed sheet and one of her white "newlywed" negligees to the location shoot (she had no studio at the time). Understanding how light would "iron" the sheet in the finished

Left—When Ana had this postcard printed, she did not yet have a business logo. *Right*—All of Ana's marketing materials now carry her "brand," which helps her business to stand out as unique and presents an "imprint" for viewer's brains.

photo, she placed the girl in front and pinned the nightgown with one of her own hairclips. Voila! She sent out the cards and reaped the reward of attracting her first customers. Many clients continue to return, several years later.

STAYING IN TOUCH DOESN'T HAVE

TO BE EXPENSIVE, BUT IT TAKES

TIME AND THOUGHT.

TIP #90

More spending doesn't equate to greater success.

Be cautious with your marketing dollar—marketing campaigns can ravage the budget. The following tips provide a few exemplary free and low-cost strategies. Marketing doesn't have to cost money to be effective.

TIP #91

Build a resource file of marketing ideas.

Create a resource file of marketing ideas you run across while reading professional photography magazines or attending workshops or conventions. Collect marketing strategies targeted to photography clients. Use those that fit your business model. Review the file from time to time to get inspiration, refocus your efforts, and motivate yourself.

TIP #92

Track your results to determine your success rate.

How many postcards were sent out? What mailing list was used? What was the cost? What was the percentage of return for each method? How many inquiries did you or your studio receive? How many actual sessions were booked as a result of your marketing method?

TIP #93

Send out periodic (not weekly) e-mail announcements.

No postage necessary! The Internet makes marketing campaigns affordable. Learn how to pull them off effectively. Special holiday promotions (Easter, Father's Day, Mother's Day, etc.) become monumentally successful with periodic e-mail blasts. Check out www.constantcontact.com.

TIP #94

Follow up with past clients to keep them coming back for more.

Don't allow your customers to forget you. Staying in touch doesn't have to be expensive, but it takes time and thought. Any professional will tell you that your most valuable clients are your current ones! Keep them interested with e-mails and special offers.

The value stored on this card may be applied toward a purchase or a photo session at Laura Popiel Photography. This card can not be refunded or redeemed for cash.

TIP #95

Offer gift cards.

Gift cards are a solid return for the investment. Who would discard a small, credit card-sized gift card with a dark strip? People attach real value to those little plastic cards.

Plastic gift cards can be ordered from Marathon Press (www.marathon press.com). They are reasonably priced in relation to the almost guaranteed high return they bring. By the way, the strip is only decorative and has no

Top—A charming thank-you card like this one is sure to elicit a smile from the recipient. Card designed by Laura Popiel. **Bottom left and right**—*Consider offering gift cards as a referral bonus for your clients. It's a win-win situation.*

magnetic capability. It does a good job to add a sense of perceived value to the card!

Following photo sessions, Laura Popiel sends her clients thank-you cards. She also lets the clients know that for every new client they refer who comes into the studio, they will receive $50 off their next photo session. Once the referred client books a session, the original client receives a gift card for $50 that can be applied to their next photo session or purchase. Be sure to include all the "rules" pertaining to use of the card.

TIP #96
Partner with retail stores.

Ana Brandt partnered with a local children's boutique to develop a promotion that is a win-win for all parties! A large poster greets customers at the door. It announces a once-a-month drawing for a free photo session at Ana's studio. (Note that it's better to not partcipate in this promotion until you have established a proven track record for producing beautiful images.) Ana's self-published book, *Creative Marketing Workbook*, is packed with promotion ideas.

"Baby doll" contests can be hosted by participating stores. Invite the mayor or local dignitary to judge. This low-cost method of advertising has steady returns. If you are a children's photographer, this promotion can really help you zero in on your target market!

Left top and bottom—Ana Brandt worked out a program with a local children's store. The customer purchases $75 in merchandise, and their name gets put into a raffle for a free session with Ana. Check state and city laws regarding raffles and contests before taking part in this type of a promotion. Right—Look what a little postcard started. Ana Brandt's continuing marketing efforts paid off. The walls of her studio in Old Tustin are covered with images of babies, children, and mothers-to-be. Photo by Ana Brandt.

TIP #97

Learn to say no.

Once established, it may be in your best interest to occasionally say "no" to a request for your photographic services. That is, of course, if you can envision a greater opportunity. To illustrate, a nationally known photographer was asked to provide headshots for a national teen beauty pageant, sponsored by a popular cosmetics company. After considering the proposal, he turned it down. Why? Because he envisioned an opportunity to participate in the event in a much larger capacity.

Suggesting someone else for the headshots, he presented a plan to create glamour magazine style photographs of the thirty finalists. The larger-than-life images would be displayed on easels lining the entryway to the

Go for the gold. If organizers of a beauty pageant request headshots of the girls, grasp the opportunity to really show off your work with a flair. Create dramatic modeling images aimed to impress. Photo by the author.

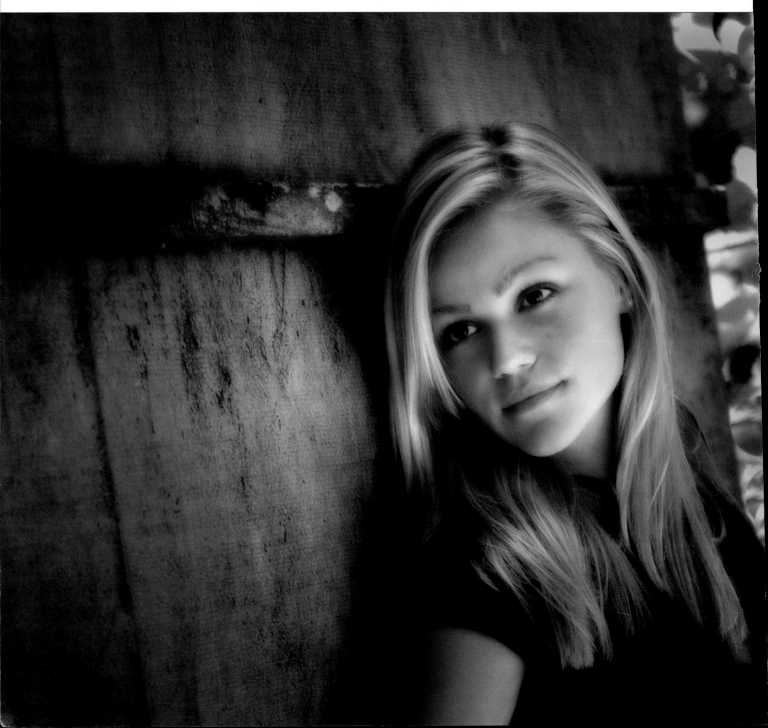

Top—This prism-shaped display provided by the Godfrey Group is affordable and transportable, filling a unique need for display in public spaces. It doesn't take up much room and fits nicely into corners. Photo courtesy of the Godfrey Group. **Bottom**—Photo by Laura Popiel.

gala banquet where the winner would be announced. His pursuit of excellence didn't stop there. He also created a knock-out DVD that featured the girls, as well as himself photographing them! The extravaganza was a roaring success and set his reputation for high-end photography with some very important dignitaries and big spenders. Compare his eventual participation in this spectacular event to the initial request for his services. Dare to think creatively and aim high to market yourself.

TIP #98

Reach out to an untapped market.

There are many photo marketing strategies out there, but none like this one. By selling greater human values, you can promote your business too.

The U.S. Census reports that approximately 20 percent of the adult population has a disability. Adding children with injuries and serious illnesses to the figure indicates that more than one in five of your clientele will have some sort of special need. Where are they? Though these prospective clients may not be contacting you, don't think it means they don't want heart-warming images of their children.

Some photographers may be apprehensive about photographing children who look or act differently than "typical" children. Insecurity comes mostly from fear of the unknown. Why dismiss a population that really wants your services? These children can often be easier to work with than their peers.

Special Kids Photography of America (www.specialkidsphotography .com), a nonprofit organization, was founded with the purpose of providing photographers with unique skills and technical knowledge they need to help make such a photo session easier and leave families extremely happy with the results. Involvement with special children opens up a delightful world of possibilities for you.

There may be other untapped markets for you to develop. For instance, many photographers are selling handbags, jewelry, and other accessories that appeal to the maternity and baby portrait customers. Boudoir photography—and boudoir photography parties—have gained popularity in recent years. Children's birthday photo parties have also become popular.

TIP #99

Create public service/community awareness displays and volunteer your services.

There's not much chance that a public library will grant you permission to display your photographic accomplishments unless you are Ansel Adams.

However, if you display beautiful images that help to build public awareness about a certain demographic, you are more likely to be able to set up an exhibit.

If you have photographed special children, for instance, look into getting your local library to display images of disabled persons during one of the many awareness months. March is the month that recognizes mental retardation, epilepsy, and premature babies. April is Autism Awareness Month, and October identifies a number of disorders such as Down syndrome and the general category of disability awareness. Prepare a helpful booklist for patrons of the library. Don't forget to make a little plaque that credits you for creating the display.

My previous book, *Photographing Children with Special Needs* (Amherst Media), gives photographic advice for all the major childhood disorders, including individual symptoms of each disorder that would meet criteria for one of the major conditions mentioned above.

Many photographers are reaping the rewards of giving to others. Kathleen and Jeff Hawkins create images for the Heart Gallery of Metro Orlando, an innovative photo exhibit that features images of children in central Florida's foster care system awaiting adoption. Photographer Kevin Kubota takes photographs for the Sparrow Clubs, a youth-based charity that provides financial and emotional support for critically ill kids and their family. Other pros choose to volunteer their services to take photos of babies who never leave the hospital, providing their parents and families with a cherished portrait. (Visit www.nowilaymedowntosleep.com for more information.) There are countless groups that could benefit from the skills of a professional photographer. Make a call. Community education/service is the kindest, most responsible form of advertising your business.

MANY PHOTOGRAPHERS ARE REAPING THE REWARDS OF GIVING TO OTHERS.

TIP #100

Get free publicity instead of, or before, buying it.

You've just read about the many benefits of helping underserved populations by donating your time and photographic talent. Why not help draw attention to your work while promoting your chosen cause?

Laura Popiel built her photography business with cents and sensibility. Her professional story began when she attended a Special Kids Photography workshop. Since Laura has a disabled child of her own, SKPA's concepts moved her to do what she had long wanted to do—start a photography business.

Laura called the *Houston Chronicle* and told a reporter about her ambition to photograph special children. The reporter did not hesitate to

Left—Special children love to be models too! Laura Popiel captured Hanna in a pose that would please any fashion magazine editor. Why not hold a model shoot or beauty contest for this population? *Right*—Untraditional images work well for accessories and other add-on sales, such as blankets, pillows, place-mats, playing cards, coasters, and more. Photo collaboration by the author and students.

cover the story. Laura lined up a special child for the session. She prepared a "fact sheet" for the reporter and included pictures of her son Nicholas. That one phone call resulted in a front-page article in the feature section of the paper and was followed up by requests for stories from other papers and two television stations. All this publicity cost Laura nothing, and it launched her career as a professional photographer.

TIP #101

Look for free display opportunities.

When starting out, look for public places to display your work. Some banks offer courtesy tables or displays for customers to display information about their business. Government buildings may have spaces where you can dis-

play documentary shots of the city where you live and work. Offer to take pictures of local businesses for their advertising in exchange for photo credits in the ad, then output a large printout of the ad for display on an easel in the store. Ana Brandt receives continual inquires from portraits displayed in doctors' offices. Leave cards and brochures with additional information for the clients—usually potential family-portrait or children's photography customers—who spend time in the office looking at the portraits instead of magazines.

TIP #102

Arrange speaking engagements.

Get your foot in the door with young mothers by speaking to expectant mothers' classes at hospitals (and other groups in your community). The topic might be "How to Capture Treasured Family Moments." Provide informational handout sheets with your contact information.

TIP #103

Get free marketing advice.

Free marketing ideas are offered on the McKenna Pro web site's "Success Center" (www.mckennapro.com). Check out the sales tools and promotional ideas. *Rangefinder* and *Professional Photographer* magazines are also excellent sources for discovering successful marketing strategies from other professional photographers.

GET YOUR FOOT IN THE DOOR WITH YOUNG MOTHERS BY SPEAKING TO EXPECTANT MOTHERS' CLASSES AT HOSPITALS.

TIP #104

Marketing workshops are good investments.

The photo industry offers a plethora of workshops and instructional DVDs, which are available in all price ranges. They provide valuable information that will help you grow your business. Consider the free marketing resources while you're getting your business off the ground, then turn on the big guns when your skills and confidence are ready to handle the increased volume of business.

There's a saying that goes, "The most successful people have failed more than most." Thomas Edison knew all about failure; he experienced it often. Try different ideas and be willing to risk failure. Eventually you'll find what works best for you. A professional marketing resource worth considering are the workshops held by Marathon Press, a printing company that is also known for producing excellent marketing strategies and the means (print products) to put them into place.

Joel Eckman Maus of Studio EMP, Fullerton, CA, was at a destination wedding in Cabo where the effects of hot weather caused him to split his pants. Jokes about his predicament made the bride burst with laughter.

TIP #105

Improve your people skills.

An invaluable asset for gaining and keeping clients is how you communicate with them—and it's absolutely free! Practice is your only investment. Work on your interpersonal communications while you're at the bank, at church, or in the supermarket. High level success isn't just about taking good pictures; you must charm your clients.

Joel Eckman Maus's passion for his art helps to fuel his interactions with his clients. He says, "Photographers should just be themselves and let go. I am so totally different with a camera in my hand as compared to not. I get hyper, crazy, etc., to keep the energy high."

Should you need inspiration to come out of your shell, attend national conventions and note the way lecturers communicate with flair and magnetism. Soak it all in and carry their élan with you to your next photo session. Cantankerous children will make your day! The mother of the bride will be mesmerized by your charm. The shy senior will morph into a superhero during your photo session with him.

HIGH LEVEL SUCCESS ISN'T JUST ABOUT TAKING GOOD PICTURES; YOU MUST CHARM YOUR CLIENTS.

TIP #106

Use skits to encourage subject interaction.

Skits are a playful way for your clients to have fun with each other. Wedding photographers have been known to set up a game of "kiss tag" with the bride and groom. The groom is pulled aside and asked to go over and kiss his bride when the photographer calls, "Ready." What the groom doesn't know is that the bride has already been asked to "resist him." The fun "tug of love" ensues.

Left—A Navajo girl was asked to whisper a secret into her sister's ear. Photo by the author. *Right*—Smiles were hard to come by during this woman's session. However, her expression immediately changed when the photographer hinted there was a lizard in the corner of the room. Photo by the author.

TIP #107

Go on a "no cheese" diet.

Please, please, no cheese! Professional photographers should all go on a no cheese diet! Leave cheese to the amateurs. Ask them to say "fromage." Really purse your lips as you say it. Expand on the reactions you get. It's all part of a light exchange to break the silence and help your clients relax through animated dialog. Humorous bantering keeps them smiling from within; that's the ultimate goal—to have fun, laugh, and truly enjoy the experience of being together. Your photos will show it.

TIP #108

Learn to inspire great expressions.

Vanessa is a young lady who does not perform well in front of a camera. After more than seventy clicks, the photographer worried about a successful outcome. "Now give me a nice smile" wasn't working. A little abstract thinking turned the session around. "Hey Vanessa!" said the photographer in mock surprise, "Is that a lizard peeking out of the suitcase in the corner?" Vanessa's demeanor and facial expression immediately changed as her curiosity was redirected toward the corner of the room."

TIP #109

Collect verbal "smile catchers" and mood makers.

Encourage your subjects to smile through something funny they hear you say. Conjure up memories for couples.

Children

- Play "peek-a-boo."
- Fake a huge, long, drawn-out sneeze.
- Have a child whisper "a secret" in their sibling's ear.
- Say, "Okay, now . . . don't you dare smile."
- Give directions in a Donald Duck or other cartoon voice.
- Say silly-sounding words like, "Sausages!"
- Tell the child to say, "Yes!" to get a nice smile.
- Say, "If you smile, your mother's gonna pinch you."
- Ask, "You married yet?"
- Tell the child, "Give me some candy!"
- Ask, "Has your mother been a good girl?"

High-School Seniors

- Tell them, "Give me some attitude."
- Ask, "Got a boyfriend/girlfriend?"
- Ask, "So you're studying to be a rap musician?"

Photo by Joni and Bob Mastous.

Couples, Engagements, Bride and Groom, Etc.

- Ask the model to scream as loudly as she can. She will probably crack up afterward. That's when you start shooting.
- For more serious expressions, ask your subject questions that relate to that specific occasion. For instance, with an engaged couple, ask them to remember the first time they saw each other. (This works for 50th anniversary photos too.)
- Ask, "Any embarrassing moments on your first date?"
- Schedule the bride-to-be for an engagement shoot. Arrange for the groom to appear later as a pleasant surprise for the bride. Make certain you have your camera ready and your light will be in just the right place at that time of day. Say something like, "Well, look who's here!"
- Tell bridal shower attendees, "Say 'sex.'"
- Stand back with a long lens. Ask the couple to walk toward you (or away). Prearrange with the guy (or gal) to do something unexpected, such as suddenly sweep her off her feet or dip her back for a kiss.
- Separate the couple and whisper to each of them that they are to grab their mate's derriere. When the photographer says, "Surprise!" neither quite knows what's going to happen. This is certain to serve as an icebreaker.

ASK THE MODEL TO SCREAM AS LOUDLY AS SHE CAN. SHE WILL PROBABLY CRACK UP AFTERWARD.

Pets

- Use a squeaky toy or clicker (keep changing sounds).
- Talk in a high-pitched voice.
- Whisper the pet's name.
- A dog's ears will perk up when you call, "kitty-kitty."
- Make a bird call.
- Put some peanut butter on the roof of a dog's mouth for some lickin' good shots.

Group Shots

- Ask, "Who can say 'A bossy black bug bit a big black bear?'" Next, say, "Okay . . . that didn't work. Just say, 'toy boat.'" When that's accomplished, say, "Easy, Huh? Now say it three times in a row."
- Say, "Okay . . . on the count of *three*," then click the shutter on *one*.

The Other "Seniors"

- Remember that first kiss.
- Do you remember sitting at the soda fountain together?

After the photo shoot, Kerri Kirshner was preparing to leave when she looked over and saw the mother tenderly nuzzling her son's nose. She peeked over and whispered, "Wait, stay right there; that's it!" That picture ended up being the best of the session. The boy passed away a year later, leaving the family with this beautiful remembrance of their very special child. The photo was later used on a poster for a community organization that provides assistance for families with children who have disabilities. The moment would have been missed if the photographer had not spotted the opportunity.

TIP #110

Always be on the lookout for great images.

Don't put your eyes back into the bag with the camera! The eye is a free "accessory" you carry with you wherever you go. Always scan your environment, noting the unique formation of objects, shadow, or design. Condition yourself to see uniqueness in commonplace items, even though someone next to you may mutter, "Huh? You're taking a picture of *that?*"

Jon Haverstick of Santa Ana, CA, has the unique ability to spot an image and turn the ordinary into extraordinary. He truly has an eye for conceptualizing a finished image when seeing everyday objects. Using the process of HDR (High Definition Resolution), he can turn just about anything he envisions into a work of art.

Facing page—*Simone Carillo casually snapped these family pictures at the beach house. No special cropping was given these images. This young mother has a gift for seeing the photo in her mind and the energy to go get her camera and capture it, even when immersed in the day-to-day demands of motherhood.* ***Above***—*Just a yellow VW bus in a parking lot? No; it shouts out, "California" and "Beach Boys." Photo by Jon Haverstick.*

TIP #111

A trained eye is the most valuable tool.

Train your eye to spot a winning photograph. A good eye contributes greatly to the success of in-demand and highly paid photographers. The most expensive camera and lenses will not make up for the lack of spotting a unique moment in a person's life and acting spontaneously to capture that image. Connect your eye to the creative side of your brain and keep the motor running.

TIP #112

Don't take all the advice that comes your way.

Most of us have been advised, at some point in our careers (or training), to sit back and wait for the right photo opportunity to present itself. This was solid money-saving advice when we had to pay for every roll of film we ran through our cameras, then send the rolls off to the lab. Today, the argument doesn't hold much water. More shots equal more sales opportunities and increased artistic freedom.

TIP #113

Explore the "unseen" in your photographs.

Be receptive to the "alter image" of your photos. Opportunities abound, especially in your outtakes.

TIP #114

Think quick, save a shot.

The moment was there. The light was right (a window). The background (the floor) stunk. How could something black be shoved under the boy's

hand as he connected with his one-week old baby sister? "Quick, run and get me something black—anything!" Dad's black t-shirt was used to rescue the image. Finishing effects were applied with Nik Software Inc.'s Monday Morning filter.

Dad's black t-shirt was used as a background for this image and saved the shot. Finishing effects were applied with Nik Software Inc.'s Monday Morning filter. Photo by the author.

TIP #115

Save your leftovers.

Saving an image doesn't always mean switching heads in Photoshop. Sometimes dramatic cropping can save a photo, so train yourself to see all of the creative opportunities a photo presents. Oddly shaped images are popular these days, especially with youth and other "open-minded" clients. Of the many images captured during a mother-and-daughter session, the image on the left was printed as a 16x20-inch canvas wrap. There was another photo in which the girl looked great but the mom did not look her best. The photographer couldn't resist saving the girl. It took seconds to crop and apply a Nik Software Inc. filter in Photoshop.

The image of this mom and daughter turned out wonderfully. In another shot from the session, however, the two subjects each turned slightly away from one another, creating a less than ideal portrait. All was not lost. Some creative cropping and conversion from color to black & white created an edgy "slice of life" look that has a lot of teen appeal. Photos by the author.

Kerri Kirshner decided to inch slowly forward toward her studio dream. She moved her living quarters downstairs and turned her "parlor" into a studio. She plans to eventually rebuild and enlarge the entire structure. The property grounds are spacious and lined with evergreen trees. This is an example of a photographer who is able to think out of the (soft)box. Photo by Kerri Kirshner.

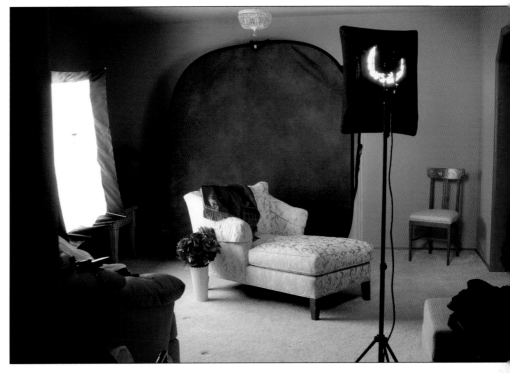

TIP #116

Don't open a studio until you are certain you are ready.

That should read, "Don't open a studio until you are bursting at the seams and are going out of your mind with work and there isn't room for people to stand in line while waiting to have their pictures taken."

TIP #117

Think hard before opting for a storefront studio.

Owning a studio may be every photographer's dream, but that dream can become a nightmare. The cost of rent, insurance, upkeep, etc., can eat up all of your profits, and then some. Of course, there are also obvious perks associated with owning a storefront studio: The ambiance usually makes it possible to charge more for sessions, prints, and products. Also, it's more comfortable for the client, and a happy client more readily parts with his or her money.

Noted photographer Tony Corbell says, "Depending on the type of business being started, it isn't critical to have a storefront location. In my commercial work, over 90 percent of my business was on location. Of course in a traditional portrait studio, a good location helps tremendously. The right location may be expensive depending on the clientele being pursued."

Professional Photographers of America is an organization that is known to look out for professional photographers. The organization conducted

their Studio Financial Benchmark Survey, which was based on information provided by one hundred and eighty photographers whose businesses had generated at least $25,000 in gross sales in 2004, with at least 50 percent of their income from portrait and/or wedding photography. The survey found that owners' compensation and net profits were "less than stellar" for 2005. Home-based studios averaged gross sales of $129,394, with an annual net profit plus owners' compensation of $32,977 (25 percent of gross sales). Retail locations averaged even less, at 19.3 percent of gross sales.

There are alternatives to storefront studios. You may consider operating a home-based studio or garage studio (check city ordinances pertaining to these options), or you might choose to operate a mobile studio. Alternatively, you can conduct all of your sessions on location, eliminating rent and other overhead costs entirely.

Photographers open studios at all stages of their career. Joel Maus, after nine years in business, hung out a shingle in Fullerton, CA, down the street from his home. His wife played a significant role in the entire process. Here's what Joel says about her in his blog:

Attention to detail in the reception area at Studio EMP gives it the rustic, old European look that is irresistible to young couples who have the income and desire to invest in their wedding and family as it grows. The décor also creates a strong lure for portrait and commercial clients who appreciate great photography and are prepared to pay for it. Photo by Studio EMP.

"Jeni saw this dilapidated old building over a year ago and wouldn't let it go until we were in (that's how we got our house too!). She is such a champ—she would come home day after day with paint all over her, hair in a bun, take care of the kids, and get ready to do it all again the next day. Staining the floor was the craziest; she was on her hands and knees for days and days, first cleaning and grinding the concrete then cleaning again and staining, then rubbing stain off to get that worn look, then once more to put the final sealer on."

You guessed it; Joel and Jeni are young. Joel's designer/builder brother, Jeremy, helped too, making the entire project a grand family effort. The results are outstanding. Many photographers choose older homes or warehouses for their studio, as in the delightful nouveau-rustique charm of Studio EMP's 1905 billiard and bowling bar. Old structures take fixing up, but artsy ambience makes them enticing.

Amy Cantrell, well-known photographer of celebrities, has a studio in her garage. She also photographs in the homes of her clients: Karl Malden, Robert Wagner, George Burns, and Jack Palance, to name a few.

TIP #118

Consider a quaint or artsy studio location.

When the time is right for opening a studio outside the home, photographers seem to gravitate toward "quaint" locations, buildings with historic ties, or at least a lot of ambiance and charm. The studio of Jeff and Kathleen Hawkins near Orlando, FL, fits this description. Although they would prefer more space, their studio suits their business model well and is located in a beautiful artisan-like neighborhood.

*Left—Amy Cantrell's elite clientele is not deterred by the studio she has set up in her garage. Her web site shows that she has also visited the homes of many actors to capture unique images in the comfort of their own environment. Photos by Amy Cantrell. **Right**—Studio of Jeff and Kathleen Hawkins, Longwood, FL, just north of Orlando. Photo by Jeff Hawkins Photography.*

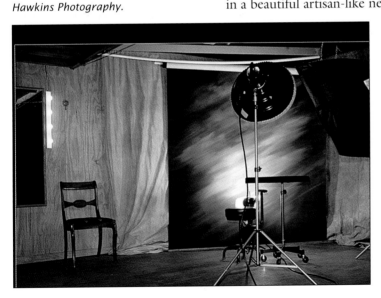

Stephanie Clark opened a garage photo studio in 2002. While this outstanding photographer's business was growing, so were her children. It is said that there was always a camera tucked away in the children's diaper bag. She began her business photographing her friends' children, then her friends' friends' children. One thing led to another until she outgrew the quarters in the garage and moved her studio to a 1917 building listed on

the National Historic Register. Though the property was originally appraised at over $7 million, she was able to purchase it for a fraction of the value (Jeff Kent, *Professional Photographer*, Oct. 2007).

TIP #119

Make good use of your studio's surroundings for shooting areas.

Here's another success story of a photographer who started out modestly. Laura Popiel began her career photographing special children on location in 2001. She eventually moved to a larger home where clients were photographed in a large upstairs room. After looking for several years and agonizing over several failed real estate deals, in 2007 she was able to purchase a fairly new home that she uses only for a studio. Located on 1.5 acres of rural property, with several carefully planned outdoor shooting areas, she now says, "It was all worth the wait."

TIP #120

Be on the lookout for objects you can adapt for photographic purposes.

Nancy Vorland, marketing manager for McKenna Pro, spotted a plate rack in a store and saw it as a potential display for a couple of 10x20-inch photographs. It also had convenient hooks for hanging a photo purse. (*Note:* When ordering large prints that will stand alone, prevent eventual bowing

Laura Popiel, after eight years of planning, now has oodles of shooting space. She saved $1,000s in landscaping fees by designing and planting each "color station" herself. The vines will eventually trellis over her English garden in the middle. Her husband mows the lawn but continues to face the challenge of avoiding cutting crop circles into the sod. Photos by the author.

by having them mounted on Gater-board (thicker than matboard).

TIP #121

Effective print displays sell larger wall art.

Putting a little time and effort into creating effective print displays in your studio can help you to maximize your profits. In her October 2007 *Professional Photographer* article about photographer Kerry Brett, author Lorna Gentry provided numerous sale-enhancing options: (1) Dramatic lighting will provide impact for the portraits. (2) Display prints in appropriate framing. (3) Add interest to your portrait cluster by hanging odd numbers of prints. (4) Increase the visual impact by

Left—A plate rack becomes a fine place to display photos or hang items you offer for sale in your studio. Photo by Nancy Vorland. *Below*—The lighting inside Elizabeth and Trey Homan's studio emphasizes their impressive wall portraits. The sale of large prints like these is a sure sign of a successful photography business. Photo by Artistic Images.

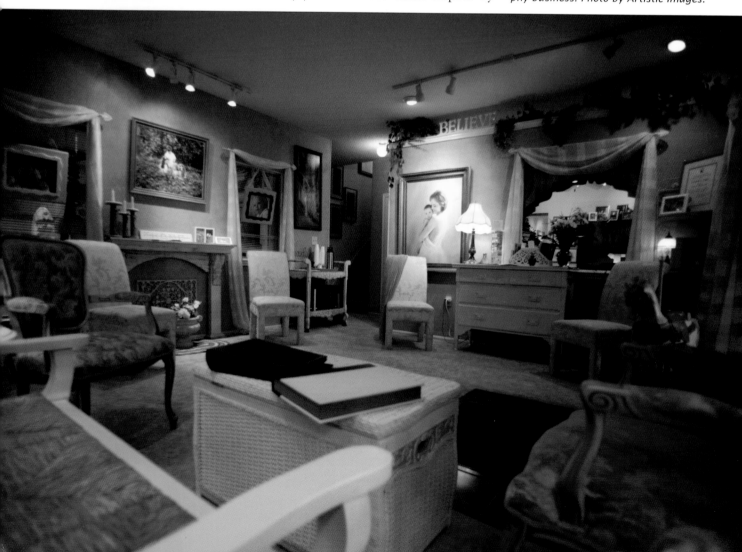

Portrait pen tracks install easily. Setup requires at least two people, but the task is better accomplished with four helpers because of the length of track required. Photos by the author.

hanging groupings by theme. (5) Hang most prints at eye level [the center of the image should be positioned at roughly fifty inches]. (6) Create depth with draperies. (7) Use small spaces (e.g., bathrooms) to illustrate the creative use of small prints. (8) Angle pieces of furniture away from walls to create leading lines and intimate spaces. (9) Incandescent lamps create a cozier and more intimate atmosphere than fluorescents. (10) A couch is the most useful tool for selling larger prints. A well-framed 30x60-inch portrait is the ideal size to hang above an average sized couch!

TIP #122

Build a "portrait pen" in your studio or garage.

Want to invite clients into your garage but don't want to reveal all your clutter? A U-shaped "portrait pen" will address that need. The U-shaped "background" will allow you to completely surround your subject. With the right light, you can shoot from any angle. Also, this handy surround can help you photograph on-the-go kids; with you positioned at the open section of the U shape, the young subject will always have a background behind them, and your position will keep them on the set.

You can order track to make the pen from a hospital supply company or from the Backdrop Outlet (www.backdropoutlet.com) or hospital equipment supplier (search for "privacy curtains").

Here's how to build the pen:

Purchase five pieces of 6-foot track and two rounded corner tracks. Drill holes (a little larger than the width of the screws) at three-foot intervals and at the ends of the tracks. Use the accompanying coupler pieces to join the bottom of the "U" sections together. (You can use a dab of E6000 glue to secure the coupled pieces.) Repeat the process with the side sections.

To install the unit, pre-mark the ceiling through the drill holes in the U-shaped track, then drill the holes and install expandable drywall anchors.

With the aid of some helping hands, hold the track against the ceiling and screw it into place. Next, insert the gliders (with attached hooks) into the track. (The tracks normally come with these, but you will need to order more.) Finally, insert the "plugs" in each end of the track to keep the gliders from escaping. (*Note:* Depending on your lighting arrangements, you may want to hang a piece of large 4x8 thick foamcore from the ceiling for bouncing light.)

Once the unit is installed, it is time to attach the backdrop fabric. Black faux suede is a good first choice, as are the canvas curtains which can be easily found at many big-box stores. As a general guideline, you should use three fabric panels (one 10x20-foot length for the center and two 10x10-foot lengths) for your backdrop. To attach this material, install grommets in the fabric and hang it up. (If the fabric is not long enough to reach from the ceiling to the floor, tie nylon cord through the grommets and attach the cord to the hooks. If desired, you can attach lengths of chain from the ceiling to pull the curtain up and out of the way for storage when not in use. (This way, your car will still fit in the garage!)

To further enhance the unit, consider purchasing other fabric panels, using posing blocks or studio risers (see below), or installing a piece or carpet for subject comfort (and for seated or reclining poses).

TIP #123
Construct portable studio risers.
Achieving varying head heights is the goal when photographing groups. Consider introducing home-made risers to help you achieve this goal. Stacy

Stacy Bratton of Dallas, TX, used plywood to construct portable, stackable risers. They even have convenient handles for easy relocation. Note how the seams and folds of black fabric readily blend into each other for easy post-processing of a portrait. Close by is a simple piece of white foamcore used as a reflector. A larger piece of board is hanging flat from the beams in the ceiling (not shown). Left-hand photo by Stacy Bratton. Right-hand photos by the author.

The contents of Tom Perkins's mobile studio make it easy for him to work on location. Photo by Tom Perkins.

Bratton used plywood to construct lightweight, stackable risers. You can do it, too.

TIP #124

Create a studio on wheels.

"Have studio, will travel," says Tom Perkins, Canyon Country, CA, who put together his own mobile studio. The contents of Tom's studio make it easy for him to photograph portrait subjects of all ages. Note that a mobile studio might help you branch out to serve new portrait demographics. It can really come in handy for traveling to a baseball diamond, for instance, to photograph individual players in their uniforms before a game, for photographing school events, or even to photograph pets.

The contents of your mobile studio may vary from Tom's, depending on your niche. Here's what Tom relies on to get the job done: *Equipment*—Three camera bags containing cameras, lenses, and supporting gear; monopod and tripod, and ten 8-pound sandbags. *Lighting*—A Photogenic three-light system with collapsible light boxes and hair light in a rolling case, One 10x36-inch Larson light box with egg crate baffle, two 13-foot light stands, two silver umbrellas, a 4x6-foot reflector, and a gobo stand and gobos in three sizes, plus over 200 feet of electrical cords to power the units. *Posing*—Two baby "boppies" (a fabric-covered platform often placed on the lap while feeding baby), two adjustable posing stools, and one set of Hanson Fong posing blocks. *Backgrounds and accessories*—One background stand, three 13x10-foot backgrounds. Fabric drapes for maternity

and newborn images, plus a variety of baby accessories. *Miscellaneous*—
Two easel stands for portrait displays.

TIP #125

Use the great outdoors as you would a studio.

Scout out a variety of interesting locales in which you can conduct your
photo sessions. Interesting opportunities await, no matter your geographic
area. Try a local park, a decaying urban backdrop, an old barn, or a beach.
Consider working at more exotic destinations, too. Some photographers
book out-of-town sessions at desirable locations, building the travel costs
into the client's session fee. Enterprising photographers book numerous
sessions at the destination. This way, the photographer's costs can be di-
vided among all of the clients, making it more financially feasible for more
of their clients.

TIP #126

Create a studio setting in your client's home.

If you don't have a studio and do all of your work on location, consider set-
ting up your client's session at her home. Chances are, you'll find a blank

*Create this image in a studio? Why? Jon
Haverstick selected an ideal outdoor set-
ting for this unique portrait that would
have taken hours and sizeable budget to
set up in a studio (plus "shopping" time).*

Left—A few items were removed from the client's wall to allow for a solid-colored, nondistracting background. Sliding glass doors on the left provided the exact lighting conditions the photographer was looking for. Photo by the author. *Right*—If there is no blank wall you can use, position the subject near a window with soft light coming in, get up on a chair, and photograph from a high angle. Surely, the floor can be cleared of any clutter to allow for the shot! Photo by the author.

wall (or one from which any artwork can be temporarily removed) near a window that will be a suitable portrait location.

TIP #127

Small items can be photographed in small spaces.

A photographer specializing in jewelry might only need a "mini" studio—roughly the size of a large walk-in closet, or even a light tent, which can be easily put into service just about anywhere, indoors or out, to create a studio-like backdrop.

TIP #128

Photojournalistic photography doesn't require a studio.

Photojournalists practice their craft on location. They focus on the natural, day-to-day lives of their subjects to create a storytelling feel in their images.

Margaret Bourke-White is a classic example of documentary photography. She began as a freelance shooter for *Fortune* magazine and then went on to land a job for the fledgling new publication, *Life,* in 1936. Her photograph of Fort Peck Dam graced the cover of the magazine's first issue.

93

The documentary style is very popular with brides and grooms. When the approach became popular, young, affluent couples rejoiced at being able to find a photojournalistic photographer to whom they could pay many thousands of dollars to document their wedding with a "free spirit" attitude. Outstanding in their field of documentary wedding photography (and recognized world-wide) are Mike Colón (Newport Beach, CA) and Joe Buissink (Los Angeles, CA).

Today, the style is also used for children's and family portraits. Calculate what a documentary photographer saves in studio backgrounds, sets, lighting, rent, electricity, etc. Working with a 70–200mm f/2.8 lens will allow you to get tight shots without standing in the subject's personal space.

TIP #129

Don't underestimate the important role the background plays.

You may want your subjects to be the very center of interest. However, during your personal creative process prior to a photo session, take care to give as much consideration to the background as to the subject. The background may complete the story, or in some cases, tell the story. Think of the person who will be in front of your lens. Consider the message you or the subject want to give viewers. What are the client's interests? What special feelings do they want to convey?

TIP #130

Seek background inspiration from the masters.

Masters of painting thrill photographers who seek inspiration. Seventeenth-Century painter Jan Vermeer was not only a master of paint, but also of light. His paintings were stories as well as moral lessons. He portrayed seemingly decadent scenes that had an underlying warning about fraud, cheating, and foolish behavior. He used the same painstakingly re-created map as "background" in several paintings. Props such as a table, carpet, white vase, and cello also appeared often, though arranged differently.

Read about Vermeer, a master of light and composition. Study his works and be inspired by the legacy he left.

TIP #131

Create a custom background that suits your subject.

Why not create a background especially for your subject? It doesn't cost much and it's easier than you might think. This is what makes Carl Caylor's work stand out from the pack. He is the total artist, conceiving and

"If beauty was only skin deep, every photograph would reveal the same personality. We create portraits. An artistic expression that goes past the outer layer, beyond first impressions, and into the abyss of one's defining essence."—Carl Caylor (www.photoimagesbycarl.com)

Facing page—Have fun creating an A Day in the Life portrait series. Clever titles can heighten the charm. (top left) Busted (top right) Strummin' Around (bottom left) Peek-a-boo (bottom right) Go 'way. **Below**—Carl Caylor of Iron Mountain, MI, was inspired by his own subject after he saw her shirt (with pictures of famous models on it) and learned that she was interested in modeling. He tore pages from fashion magazines and used them as the background—something this eighteen-year-old subject adored!

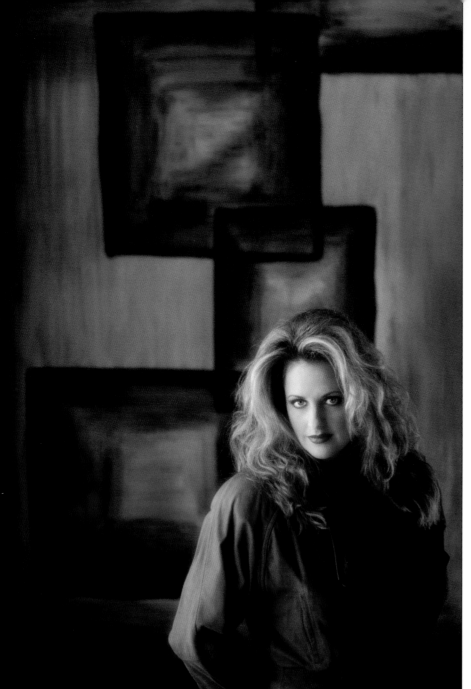

Left—Not So Square *was Carl Caylor's self-assignment that was part of a privately arranged photographic competition. Here, the background came first, and the title followed. The portrait has been widely acclaimed. A few years after he created the image, Carl saw the background offered for sale by a national distributor, complete with his title. Carl says, "Never steal from anyone. We should be inspired by others' work but never copy it."* ***Above***—Intense Perspective *was created by Carl Caylor for a portrait of photographer and artist, Scott Dupras. Carl says the concept for the background came to mind first. He had seen the underside of a train bridge and envisioned it as a striking background. There was no way to use the bridge the way he wanted, so he painted the "essence" of the bridge as his mind remembered it. It took about three hours to paint. He knew exactly where to place the subject, and his technical knowledge of light guided him in placing the dark areas to create the feeling of depth he sought. The portrait took about fifteen minutes to create and has been reprinted in various publications.*

painting the background for the subject, then creating the portrait that constitutes the consummate work of art. Carl lays out his philosophy on his web site: "This is a time to express yourself, a time to remember forever. Don't settle for average, ordinary, monotonous pictures. Together, we can create images that will always capture the interest of whoever views them."

Before taking a photo, ask yourself if the only thing the background contributes to the image is an atmosphere of professionalism for the client. There are countless background options, and they can contribute color, texture, mood, or a storytelling element to your photographs. There are no rules here. Use as a background anything that adds to the image.

Top—Expensive architectural pillars? No way! Claude Jodoin carefully covers cardboard cement casting casings that can be found at home improvement stores. His expert lighting techniques created beautiful contours on the girl and the columns. *Bottom*—Cool senior portrait backgrounds don't have to cost a lot of money. Claude Jodoin used a $1.99 "space blanket" he purchased at a pharmacy.

Top—This holiday card features a "tree dimensional" background. To create the set, the photographer inserted birch branches into a sheet of wood into which holes were drilled. A little glitter helped to create the wintry touch. Photo by Laura Popiel. **Bottom left**—Canadian photographer Sharon Wilson created a unique composition by cleverly using a $40 "old world" shower curtain as a background. **Bottom right**—Never stop "thinking" pictures—even when having a pleasant breakfast with your daughter. This restaurant displays two fiberglass panels put together with a few bolts, then spray-painted with vibrant purples and warm tones of orange and mustard. Add more oversized bolts to create an even more impressive effect! Photo by the author.

Hunt for public areas that look like expensive designer sets.

There are certain advantages associated with photographic sets: they are realistic and lightweight, making them easy to move around the studio. There are some downsides associated with their use, as well: life-sized sets

require a giant studio to accommodate them and a warehouse for off-season storage. Before investing in these sets, look to get feedback from other photographers who use them.

An alternate suggestion is to look around your own community for locations that offer the same "look" that sets provide. Think of clever ways to achieve a similar design element in your photograph. When you

Top—This environmental image was captured at a heritage park in Phoenix, AZ. Late-afternoon sun provided warm light and created the long shadows. Photo by Sally Harding. **Bottom**—Lisa Jane Murphy's lovely and spacious photographic "compound" in Houston, TX, has plenty of room for setting up a set of realistic-looking railroad track props, complete with a Railroad Crossing sign and a switcher. The investment in these tracks have certainly paid off for her. Photo by Lisa Jane Murphy.

find a suitable "set," make note of the best time of day to photograph in that location.

TIP #133

"Cool" backgrounds are easy to create using found items.

Gather a collection of items you have in the garage that have interesting negative spaces (e.g., old lace, a leaf rake, broken wrought-iron elements, etc.), plus a king-sized sheet and a few cans of spray paint. Hang the sheet between some trees (on a very calm day) or in the garage with the door open. (Be sure to wear a mask before you begin painting.) Look at the objects you've gathered and come up with a design scheme. (Will there be a hot spot in the middle where the model will stand, or will there be an overall pattern or design?) With your arms covered, spray through the item to create a design on the sheet. Repeat the process with other objects, always stepping back to see how the project is progressing. Once you are finished, you can spread the sheet on the floor and stamp designs with vinyl paint to add interest. Be cautious when undertaking this step. Make sure the color(s) used do not contrast too much, and stamp lightly to ensure you do not add dark, undistinguishable blobs of color on your masterpiece.

Assemble a large cotton bedsheet, a few cans of paint, and assorted items that can be used to create a pattern when paint is sprayed over them. The paint is more easily applied when a "trigger" tool is attached to the can (see small photo, above). Photos by the author.

Create a canvas-like background, starting with only two colors of paint.

This is a simple background to create using two gallons of "oops" vinyl paint (in contrasting colors) from the hardware store (you can also use your leftover paints) and a flat bedsheet. Have on hand two to four empty paint cans or disposable plastic containers, which will be used for mixing colors.

To start, place the sheet on top of a thin tarp on the floor. (The folds on a thick tarp will create lines when you are painting.) Use a paint roller to cover the sheet with one of the two shades of paint. Next, mix the two paint colors to create a third shade. Repeat the process again, creating a fourth shade, by altering the ratio of color A to color B. (Repeat as often as you wish.) If you wish, you can add a little water to the mixtures to produce a weaker, more subtle effect. Finally, dip a crumpled rag or large sea sponge in paint and apply patches of color. Take care to blend in the colors and avoid harsh edges. Let your imagination run free!

TIP #135

Old window frames have many uses.

Hang or build a stand for a vintage window frame (with glass or empty). Place your subject behind it, or in front of it. If photographing your subject in front of the window, tape or staple a piece of muslin or semiopaque fabric behind the frame and place a light behind the window to give the impression of sunlight. If desired, fill in the background with inexpensive, cotton/polyester sheers.

TIP #136

Get friends and relatives to do "background checks."

Laura Popiel's daughter made a thrilling find (for a photographer) at a salvage yard, and after phoning for approval, negotiated a deal for her mother. The beautifully weathered tin panels (shown on the left) make a charming photographic background—no shine and great texture. Plastic replicas are available from a DIY store but are quite pricey—and very shiny!

TIP #137

Save money on high-end photographic costuming by skipping sizes.

"Fantasy" costumes are popular for children's portraits. Photographers who provide clothing for their clients have found a niche and maintain

Weathered panels like these can be found at architectural salvage yards. A unique background like this will help set your work apart from the ho-hum portraitist's images. Photo by the author.

Top—Give your "start-up" budget a break by concentrating on bringing out the personality of a child dressed in an adorable or funky hat. Stacy Bratton has a large collection of unique hats to use for her sessions with babies. **Bottom left**—Fantasy costumes are a hit with many parents. Others prefer an "everyday" feel. Photographer Trish Reda's own daughter wouldn't remove her wardrobe selection of the day. She is also wearing a bit of attitude in this image, which is a top pick in Trish's portfolio. **Bottom right**—Many photographers and parents prefer to have babies photographed in the nude; no costume required! Photo by Stacy Bratton.

their investment is well worth it. Unfortunately, the cost of special wardrobe items can strain a new business owner's budget. The happy news is that many of these specialty items expand or cinch with decorative lacing, a feature that will also "stretch" your budget. Note that, fortunately,

specialty portrait clothing has a strong reputation for being well-made and can weather the many necessary trips to the dry cleaners.

To add pizazz to an ordinary portrait, assemble a collection of funky hats or other one-size-fits-most items. Sometimes a simple addition can make an uninteresting portrait more interesting.

Fantasy sessions need not be limited to young clients. Some adults like to get in on the act too. On the other hand, Lisa Jane Murphy has limited the fantasy portion of her business to children who are seven years of age

Laura Popiel created a feathery fantasy with a set of adult angel wings from Posh Props.

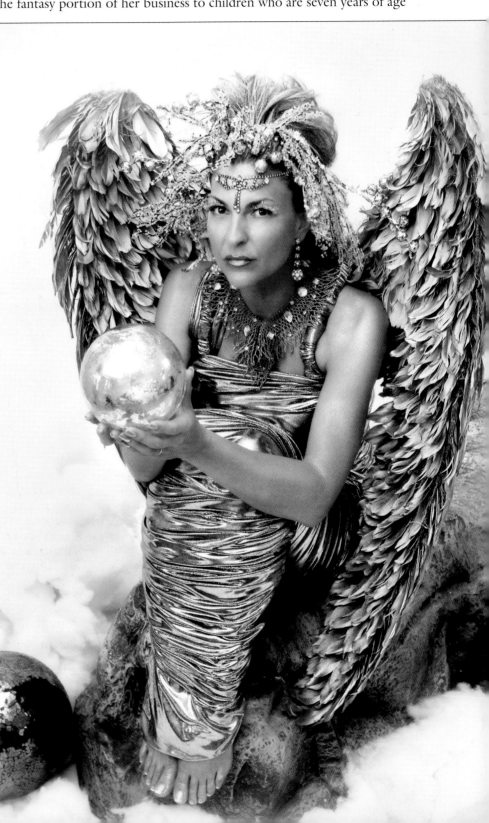

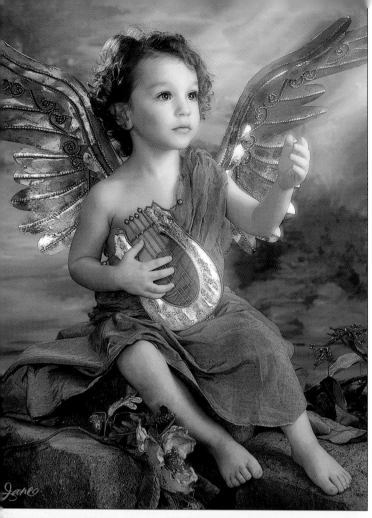

Above left and right—At Lisa Jane Murphy's studio, she uses rooms, not closets, to store her many fantasy costumes. By limiting fantasy portraits to the under-seven age group, she is able to provide ample costuming options for her clients. **Bottom**—Want to cut your wardrobe costs? Consider having your young clients dress up in mommy's or daddy's clothes for a memorable session. Photo by Diane Graham.

and younger. This indicates to customers that only certain sizes of costumes may be available.

TIP #138

Take a seat (or not)!

Chairs and expensive benches need not be a part of your props collection when you are new to the business, or at any time, for that matter. Thomas Balsamo has been in business for many years, and he still loves to pose his subjects on the floor. He concentrates on cultivating a great interaction and captures "a look inside the soul" through the eyes of his subjects.

Above—Even though props are not involved in this image, Rose Hyc of Dixon, CA, has brought curves and shapes into the composition, lending more of an artist's interpretation to her work. ***Top and bottom right***—Chairs are rarely seen in the images by Thomas Balsamo. Most of the time, subjects are on the floor or the head is tightly cropped, drawing focus to the eyes.

Facing page—*Keep your eyes open for great seating options. Always consider sturdy nontraditional options for added interest in your portraits. Photos by the author.* **Above**—*This man was happy as a bug in a rug to be posing on a pile of aged manure. His loving wife was pleased to be at his side as he relived his happy childhood on a farm. The couple ended up purchasing a set of three images that included an old pump, large iron chain, and other items that reminded him of days of yore. Photo by the author.*

That said, there are some benefits to using chairs for posing your clients. These props can add visual interest in the frame and can help you to stagger head heights when photographing multiple subjects.

Pictured on the facing page are numerous inexpensive finds that could serve as seating options. When stocking your studio with seating options, avoid buying antiques unless they have thrift-store price tags.

Tip #139

Only portions of objects are needed to hint at a "set."

Elizabeth and Trey Homan's studio, Artistic Images, is located on two wooded acres in San Antonio, TX. The property's expanse and features

Left—A yard or two of inexpensive tulle allows for a little modesty in a nude baby portrait. It can also help keep the baby entertained. Photo by the author. **Top and bottom right**—*Dan Simkin of Atlanta, GA, built these Easter sets out of wood from apple crates found behind a market and generously applied a few coats of white paint. Total cost: about $5. The days of wooden apple crates may be gone, but there is still scrap lumber to be found, whether retrieved from a construction site dumpster or left over from a DIY project.*

make it a great location for sessions. Not everyone is blessed with so much space, however. Note that sometimes, all it takes to hint at an expensive or expansive set is a glimpse of a mood-setting element such as a wagon wheel or a piece of a fence.

TIP #140

Soothing a fussy baby with a vibrating pillow may help you avoid rescheduling.

Mom and dad can become a little bit stressed when their baby begins to fuss during the photo session. The infant can pick up on this energy and become fussier still! This vicious cycle can lead to a frazzled photographer. Before you throw in the towel and decide to reschedule the session, try laying the baby atop a fabric-covered vibrating pillow.

TIP #141

Wearable art serves as mobile advertising for the photographer.

Professional photographers have found that moms, grandmothers, and other proud friends and family appreciate the opportunity to carry a purse adorned with that special baby's photo. Also popular are bracelets and

necklaces with a loved one's photo. Review hot fashion accessories and other add-on items—from throw blankets and pillows to coasters, mugs, playing cards, and more—at photographic trade shows during national conventions.

TIP #142

Offer photo handbags that can be updated as the child grows.
Photo handbags featuring images of your client's babies or children are popular add-on items. Some brands are very pricey, but women still buy

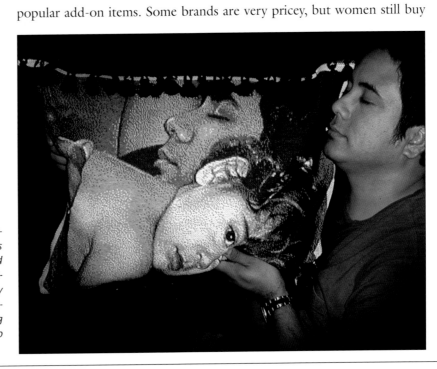

Top—*There's a photo product for everyone. You can now have your photos printed on throws, pillows, jewelry, and handbags. Photo by the author.* **Bottom**—*This trendy handbag is not only fashionable—it's versatile, too! The replacable flap is practical for changing out images of growing children. Photo courtesy of McKenna Pro.*

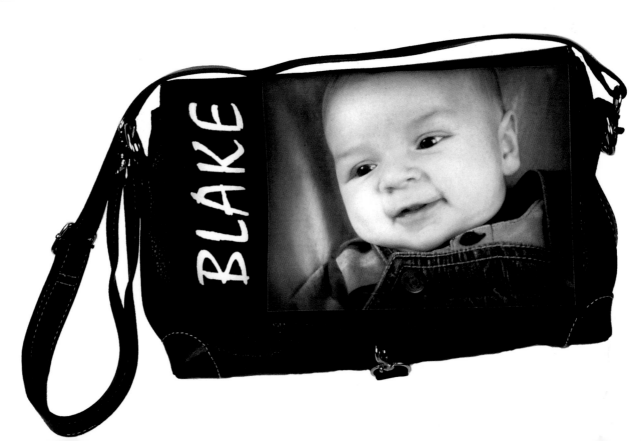

them. The child grows up, and the bag only grows old. One company, McKenna Pro Labs, offers photo handbags in a variety of shapes and sizes featuring a removable picture flap that allows for the image to be affordably updated.

TIP #143

Consider the high return framing brings.

Carl Caylor's lovely home in Iron Mountain, MI, features a studio with impressive north facing windows for capturing his subjects in beautiful, natural light. Carl tells how he felt his portraiture, alone, was all he need to sell to his clients . . . until one day he was at the framing shop and noticed one of his large, wall-sized images with a price tag that was more than what he charged for the portrait! That's when he decided to include framing as an added service for his customers.

The mark-up on custom framing from wholesale to retail is more than double and commonly reaches three times or more than the actual cost. Framing charges are determined by the reputation of the studio, the clientele, and the real estate values in the area. (*Caution:* No matter the charge for framing, make certain it is all prepaid prior to ordering.)

TIP #144

Don't stock up on frames—no matter how good the deal!

Sad story: A photographer who was new to the business heard about a fantastic buy on frames. He bought hundreds. Understand, it was a *very, very*

*Left—Framing isn't as intimidating as it may seem. Artistic Images, San Antonio, TX, has a separate room where their customers can review framing options in comfort. Photo by Artistic Images—Portraits by Elizabeth Homan. **Right**—Choose a wall where you can hang corner moulding from frame manufacturers. Samples are inexpensive and are a convenient sales tool. If you do not have a wall that can be used for this purpose, create a portable display. Cover a large piece of Gatorfoam in a fabric that can be used with Velcro strips to hold the corners in place (outdoor carpet will also work, but is difficult to finish off on the edges). Photo by the author.*

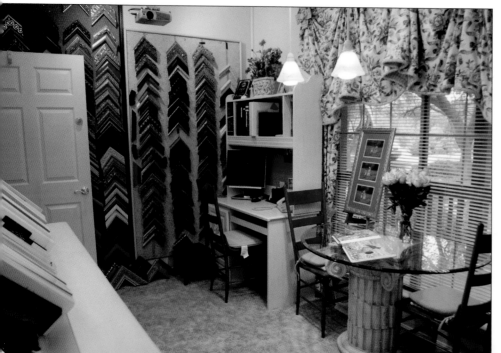

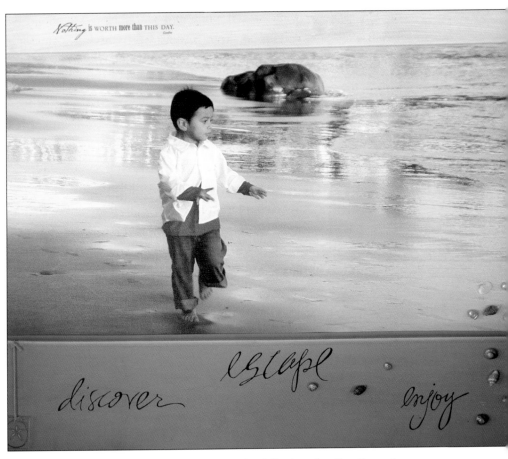

Left—Create your own canvas-style portrait by following the directions shown below. Be sure to order your print from a professional lab if you don't have a quality printer. Also, take care not to use water-based glue, as it will cause buckling. Photos by the author. *Right*—Ana Brandt had Simply Canvas print her photograph on an 16x20-inch canvas, wrapping the image around the 1½-inch deep sides. This presentation of portraiture is called a gallery wrap. The blank canvas background on top and bottom of the photograph is painted and embellished in keeping with the subject matter or to complement the child's room.

good deal! For the next several years, he paid warehouse rental fees to store them while they cracked, chipped, separated at the corners, and utterly rotted away into uselessness. Who was the one who got framed here?

TIP #145

Canvas wraps bring in extra profits.

Portraits printed on canvas and stretched around frames are called canvas wraps or gallery wraps. Two depths of frames are generally offered by the labs that provide this product, ¾ and 1½ inches. Watch for special promotions at trade shows and through the Internet!

To make your own canvas wrap in-house, purchase 1½-inch blank wrapped canvas at an art or craft supply store. Have your chosen image professionally printed on photographic watercolor paper (www.epson.com

carries one to use on its professional photo printer). Select the desired color of acrylic craft paint and, using a sponge-type brush, carefully paint your canvas, avoiding the area over which your image will be placed. Carefully tear the edges of the print using a deckle-edge ruler or the edge of a table (practice first). Use double-sided, acid-free tape on the edges of the back of the photograph to attach the print. Affix itsy-bitsy buttons, ribbon, or other decorative touches from scrapbooking supply department, or have the mom bring items that match the child's room. (It's a good idea to show her a sample canvas portrait and have her look for similar decorative elements that will work for her print.)

Above—Book publishers and print processing labs offer books in various sizes. Most common are 7x7 inches and 8x10 inches. Sizes vary from publisher to publisher. The 7x7-inch book is full of documentary style photos with captions that are simple poems and limericks. Photo by the author. *Facing page*—Combining documentary images with charming poems creates an heirloom product for your clients. Photos and poems by the author.

TIP #146

Albums are expensive. Always collect payment up front.

Make certain the order is prepaid before ordering an album—especially the kind in which the photos are printed right on the pages. Adhesive-mount albums are more affordable but also more work on the photographer's end, with possibility of creating damage to the prints during the installation process.

TIP #147

Printed books can be impressive sales incentives.

Books are hot items. Printing technology has made bound volumes very affordable. There are many ingenious ways photographers have devised to use these books for sales incentives. However, to offer a book as an item in itself does not make good "sales sense." Here's why: A twenty- to forty-page book contains several valuable photos. You can likely make more money selling individual prints (especially framed ones!). Find creative ways to use books as a sales tool rather than as a key product. When you meet with the client to review their images, surprise her with the book. Offer a book, for example, as a thank you gift when the client's order reaches a certain price point. This investment may cost you between $20 and $50 (wholesale), but the money you can make by setting a minimum order can pay for the book, and then some! Don't try to cut costs by ordering a soft-cover book. Hard-cover books are a better investment!

TIP #148

Make a statement with your packaging.

Commercial packaging supply companies have an intriguing and artful selection of poly bags, boxes, and other packaging supplies, as well as paper sold in large rolls. Wholesale packaging companies can be found in many

A Very Sand Song

At the beach I got sand in my teeth.

It stuck to my nose—underneath.

So I spit and I spat, and shook off my hat, and the sand crab muttered,

"Good grief!"

Old Man Under the Bridge

There was an old man who sat under a bridge,

Watching dark clouds hover over the ridge.

Then . . . behind him a ripple

Sent him tipple-top-bipple

NOW *where's* the old man under the bridge?

Sand Flea Circus

There once was a circus of fleas.

All splendid performers were these.

But after the show, to a crab they said, "No!"

We'll take a DOG if you please!

major metropolitan areas. Alternatively, you can check out Uline (www .uline.com). Their rolls of corrugated wrap come in a variety of widths, all in 250-foot lengths.

TIP #149

Develop a "hand-over ritual."

The presentation of your products adds to the portrait experience. Picture this: A woman is leaving an elegant store in the mall with a handsome shopping bag over her arm. There is no mistaking where the bag originated because of the store's creative logo. She's happy to be holding that lovely package. She feels spoiled and pampered.

Create a special ritual to present your gallery-quality work of art to your favorite customer. Make every customer your favorite. This VIP treatment costs you nothing but brings you much in return.

TIP #150

Use the money you've saved.

Though photography is not considered a hazardous profession, independent photography business owners must think early on about potential illnesses and injuries. Slow-down or retirement will happen, sooner or later, no matter what. Plan for it. The money you save through careful planning and spending—and *saving*—should be put into a special account and left to grow. You will need this money to buy food, medicine, and other essentials—not another piece of equipment. Pick up a great book on saving and investing, and use the money-saving and money-making tips you've learned in this book to fund your future.

Closing Thoughts

The tips in this book are meant as a springboard in your quest to earn top dollar as a professional photographer. In order to earn big bucks, the way you dress and the way your equipment looks and performs must send clients the message that you *are a success*. With that said, you should also note that in order to succeed in the digital age, your work must look like a million dollars, too!

Contributors

Chastity Abbott (www.storybookmomentsphotog raphy.com)—As a young mother living near Kansas City, MO, Chastity Abbott has accomplished the most amazing photography with the limited amount and level of equipment and software that she has been able to afford. Her web site proves this point; she used a Rebel XT camera and Adobe Photoshop Elements to create the lovely images posted there.

Thomas Balsamo (www.portraitsbythomas.com)—Thomas Balsamo's love of portraiture and interest in people is reflected in his classic yet simple style. His objective is to capture the true personalities of his subjects, invoking a feeling that can be experienced each time his work is viewed. He has been featured on CNN, CBS, and local TV and is published in *Professional Photographer* and *Rangefinder* and has co-created books on children with autism and Down syndrome.

Anamaria Brandt (www.anabrandt.com)—Anamaria Brandt loves photographing babies, children, and expectant mothers. This Southern California photographer says, "Photography is my life." This passion shows in her self-published books, *The Art of Pregnancy and Newborn Imagery* and *Creative Marketing*. Ana has achieved recognition within professional photographers' groups and shares her excitement and talent at national conventions and workshops.

Stacy Bratton (www.stacybratton.com)—Stacy Bratton of Dallas, TX, discovered early on that the most enjoyable children's images were not the smiling or posed shots, but rather, the ones with frowns, cries, expressions of frustration, and excited looks of wonder. She uses sensory integration, a technique that explores how the senses develop, to successfully elicit and capture a child's true personality.

Amy Cantrell (www.amycantrell.com)—Amy Cantrell, an award-winning Los Angeles-based photographer, has mastered the lighting skills necessary to obtain the most dynamic and flattering images of her subjects. Her proven method has landed her coveted photo shoots with some of Hollywood's most legendary celebrities. Her clientele includes Magic Johnson, James Earl Jones, Wolfgang Puck, George Burns, and Jessica Alba.

Simone Carillo—Simone Carillo is a busy young mother who who is self-employed as a vendor in the world of high-end fashion. Despite the demands of her job, she still finds the time to spot a great image and grab her camera for instant capture.

Carl Caylor (www.photoimagesbycarl.com)—Carl Caylor, owner of Photo Images by Carl, in Iron Mountain, MI, is known for creating beautiful, timeless portraits that capture the personality and style of each client. Carl takes pride in providing priceless images to treasure and enjoy. His artistic portraiture is of the highest quality. As an expert in photographic lighting techniques, Carl is a popular presenter at conventions and workshops around the country.

Gigi Clark (www.gigiclark.com)—Gigi Clark of Oceanside, CA, has a varied background including photography, multimedia, graphic design, and conceptual art. She brings all of her multi-disciplined talents to her upscale photography business, Rituals by Design, located in Southern California. She has received numerous awards and honors, including several First Places (and Loan Collection) in both PPA and WPPI.

Tony Corbell (www.corbellproductions.com)—Since beginning his photography career over twenty-five years ago, Tony has photographed three U.S. presidents, one hundred and eighty-five world leaders, sixty-five

Nigerian heads of state, about five hundred and fifty brides and grooms, a couple of astronauts, and lots of famous and not so famous faces. Along the way Tony has spoken at over three hundred seminars and workshops nationally and in Italy, Germany, Canada, England, Ireland, the Philippines, New Zealand, and more.

___**Roger Daines**—Roger Daines is a Master Photographer who works to promote Professional Photographers of California, a PPA affiliate group that hosts the annual ProPhoto Expo in Pasadena, CA. His expertise was integral to the development of many of the money-saving tips covered in this book.

___**Diane Graham (www.dianegrahamphoto.com)**— On her beautiful ranch is Tucson, AZ, Diane Graham has constructed a stand-alone studio to match her her beautiful Southwest-style home. The structure is specially outfitted with hanging lights and other accessories to accomodate persons with disabilities.

Sally Harding—Sally Harding is a PPA Certified photographer who moved from Phoenix, AZ, where she operated Treasured Image Photography. She joined her husband in Kentucky, where they now both work in the photography/video section of the U.S. Army.

Jon C. Haverstick (www.jchphotography.word press.com)—Jon Haverstick owns and operates Jon Haverstick Photography in Santa Ana, CA. His photographic interests are wide-ranging, but he has a particular passion for high dynamic range imaging and portraiture, particularly with a minimalist kit containing off-camera speedlights. In addition to photography and his "day job," Jon teaches photography and digital image editing at Santiago Canyon College. His ever-expanding online gallery can be viewed at pbase.com/haverstick.

Jeff and Kathleen Hawkins (www.jeffhawkins .com)—Jeff and Kathleen Hawkins operate an award-winning wedding and portrait photography studio in Orlando, FL. Together, as a team, they are excited to be authors of nine published photography books. Industry sponsored, they are both very active in the photography lecture circuit and take pride in their impact in the industry and in the community.

Elizabeth and Trey Homan (www.portraitsbyeliz abeth.com)—Elizabeth and Trey Homan are the pro-

prietors of the high-grossing Artistic Images in San Antonio, TX. The Homans are regular instructors at photography schools. Elizabeth has enjoyed a rapid rise to a position as one of the top wedding and portrait photographers in the nation and was Texas' youngest Master Photographer and Photographic Craftsman. She is an award-winning portrait artist widely known for her distinctive lifestyle portraiture of families and children and her storytelling approach to wedding photography.

___**Rose Hyc (www.rose-photography.com)**—Rose Hyc, of Rose Photography in Dixon, CA, loves to capture images on location and is accredited with Special Kids Photography of America.

Dina Ivory (www.dinaivory.com)—Clients travel from across the United States to have their portraits created by Dina in Tallahassee, FL. She has worked diligently for over twenty-five years to achieve the major awards given to a professional portrait photographer within the national photographic community. Photographers nationwide have benefited from her knowledge and experience at the many marketing seminars she has presented over the years.

Claude Jodoin (www.claudejodoin.com)—Claude Jodoin is a working professional photographer and technical editor of industry-leading *Rangefinder* and *After-Capture* magazines. He is a highly sought-after writer and program presenter at professional photography conventions. Having abandoned film in 1999, he recently purchased his forty-eighth digital camera. He claims, "There are no experts in the field, only varying levels of ignorance." Claude's web site offers a wealth of inexpensive lighting solutions. His DVD, *Lighting Fundamentals,* provides basic one-light techniques.

Kerri Kirshner (www.acclaimedphotography.com)— Formerly specializing in on-location photography, Kerri Kirshner converted her home and garage in Bothwell, WA, into a full-service studio. She now focuses on photographing special children. Special thanks to Kerri for her time and efforts in helping to review and edit this book.

Joni and Bob Mastous (www.pencilandlens .com)—Joni and Bob Mastous operate a small photo and sketch art business in Prior Lake, MN. Their specialty is

photography and sketch art of children and families. They have a particular love for working with children who have special needs and are accredited by Special Kids Photography of America.

Joel Maus (www.emausphoto.com)—Joel Eckman Maus, owner of Studio EMP in Fullerton, CA, studied under great photographers such as John Upton (who studied with Ansel Adams) to learn the fundamentals of photography. Shortly after Joel started studying photography, he took his first Photoshop class. He has been hooked ever since.

Lisa Jane Murphy (www.lisajane.com)—Lisa Jane Murphy of Houston, TX, is known for her elaborate artistic creations involving angels, elves, and assorted sprites. Her splendid images are reproduced on calendars, greeting cards, and in books. She travels around the country, generously sharing her expertise and unique photographic techniques.

Kevin Newsome (www.newsomesstudio.com)—Kevin Newsome of Tampa, FL, is a Master Photographer and author of *Children's Portrait Photography: A Photojournalistic Approach,* published by Amherst Media.

Tom Perkins (www.tomperkinsphotography.com)—Tom Perkins trained in fine art portraiture and now specializes in photographing maternity images, babies, children, and families. He also participates in photographing nonprofit and corporate events. As a location photographer, he created a custom-made studio that fits into a trailer he tows behind his vehicle.

Laura Popiel (www.laurapopielphotography.com)—Laura Popiel practices her craft in Houston, TX. As a mother of a boy with Down syndrome, she began her career photographing children with special needs. She's moved into a spacious studio with lush surroundings that accommodates weddings, family portraits, and seniors.

Trish Reda (www.trishreda.com)—Trish Reda approaches her photography with a relaxed attitude and a sense of humor. She works primarily in black & white and on location, photographing all over Southern CA, as well as throughout the United States and abroad.

Dan and Micki Simkin (www.tripodphotography .com)—Dan and Micki Simkin, a husband and wife team, have been photographing children and families for thirty years. Their award-winning style of photography and attention to detail is recognized across the country. Dan has achieved the prestigious distinction of becoming a Certified Professional Photographer from PPA.

Nancy Vorland—Nancy Vorland is a former studio owner from Cedar Falls, IA, who traded her sucessful business for a career as studio marketing manager for McKenna Pro, in nearby Waterloo, IA. She now creates marketing and sales tools for the company.

Sharon Wilson—Sharon Wilson runs Wilson Studios in Paris, Ontario, Canada. She specializes in creative photography and portraiture.

Teresa Wright (www.visaliakidsrock.com)—Together, Teresa and her sister-in-law, Francine Wright, operate Kids Rock Photography in Visalia, CA.

Other Notable Photographers

Many of the photographers quoted or referred to in this book have inspiring images. Visit their web sites for more information.

Kevin Ames (www.kevinames.com)

Doug Box (www.dougbox.com)

Joe Buissink (www.joebuissink.com)

Emanuela Carratoni (www.photo.net/photodb/folder?folder_id=657830)

Stephanie Clark (www.stephanieclark.com)

Mike Colón (www.mikecolon.com)

Cherie Steinberg Coté (www.cheriephoto.com)

Martha Fitzsimon (www.marthfitzsimon.com)

Gregory Heisler (www.gregoryheisler.com)

Jen Hillenga (www.momentoimages.com)

Matthew Hummel (www.matthewhummel.com)

Jeff Kroeze (www.jeffkroeze.com)

Kevin Kubota (www.kubotaimagetools.com)

Charles Maring (www.maringphoto.com)

Ann Montieth (www.annmontieth.com)

Dave Montizambert (www.montizambert.com)

Ed Pierce (www.edpiercephoto.com)

John Ratchford (www.ratchfordphotographic.com)

Tim Walden (www.waldensphotography.com)

Resources

Resources mentioned in this book have come to our attention through their merit or may have had the luck of the draw by an Internet search engine. There may be other products or references that are just as good or even better to fit your needs. Please conduct your own research prior to selecting products or services. For product comparisons, go to www.retrevo.com.

Manufacturers listed here will have information and/or catalogs on their web site that provide details about their products. However, they may not sell directly to the public. Individuals can purchase items from distributors of photographic equipment (some represented here). Major manufacturers exhibit at national conventions and trade shows where they are happy to demonstrate their products to consumers. Distributors are also represented at trade shows, so the "looker" doesn't have to wait to shop. Some photographers attend trade shows just to get in on the great deals offered there.

Albums

Note: It's a good idea to stick with two to three album companies (one affordable, one high-end, and perhaps a funky style). Most album companies will design, print, and bind (DPB) your book. If selecting the self-mount style of album, learn the special technique of inserting the photos without damaging them. Many of the companies listed below offer this cost-saving album style.

Adorama (www.adoramapix.com)—Hardcover books. Great for beginners.
Album Crafters (www.albumcrafters.com)—DPB with a variety of covers, including metal and acrylic.
Albums Inc. (www.albumsinc.com)
Albums Unlimited (www.albumsunlimited.com)—DPB leatherette, leather, and tapestry.

Art Leather (www.artleather.com)—DPB or use free design templates, preview albums with slip-in casings also available.
Bon Match (www.bonmatchalbum.com)
Expert Albums (www.expertalbums.com)—Australian-based, offering pages with mats for slip-in photos.
Finao (www.finaoonline.com)—Albums with attitude.
GP Albums (www.gpalbums.com)—Free designer templates or DPB.
GraphiStudio (www.graphistudio.com)—Italian-based, with design services.
L & B Albums Frames Backgrounds Plus, Inc. (www.lbalbumframe.com)—Big selection of self-mount products.
Laguna Albums (www.lagunaalbums.com)
La-vie Album (www.la-viealbum.com)—DPB, some with flip-out page.
Pro Photo Albums (www.prophotoalbums.com)
TAP (www.tap-usa.com)—Albums only, mini to conventional sizes.
Zookbinders (www.zookbinders.com)—DPB or use free templates; metal covers and pages available.

Album Layout and Design Software

Note: Most album companies offer design and print services, and many now provide design templates. If the templates do not measure up to your creative prowess, use specially designed album software.

Kubota AutoalbumV3 (www.kubotaimagetools.com)
Lab Prints (www.labprints.com)—Workflow solution, interfaces photographer with lab and album companies.
Sallee Solutions (www.salleephotography.com)—Seminars also available.

Associations

*Children and Family Photographers of America
(www.cfpamerica.com)*

*Professional Photographer of America (PPA)
(www.ppa.com)*

Senior Portrait Artists (www.spartists.com)

*Wedding and Portrait Photographers of America
(WPPI) (www.wppionline.com)*

Backgrounds, Backdrops, and Props

*American Photographic Resources, Inc.
(www.aprprops.com)*

Aura Backdrops (www.aurabackdrops.com)

Backdrop Outlet (www.backdropoutlet.com)—Ceiling
tracks and carrier hooks also available.

*Back to Back Design Works, Inc. (www.backtoback
designworks.com)*—Large sets.

*Backgrounds by Maheu (www.backgroundsbymaheu
.com)*—Custom backgrounds.

Denny Manufacturing Co. (www.dennymfg.com)

Drop it Modern (www.dropitmodern.com)

eStudio Lighting (www.estudiolighting.com)—Back-
grounds and more.

Hancock Fabrics (www.hancockfabrics.com)—Wide-
width muslin and draping fabric.

Joann Fabrics (www.joann.com)—Wide-width muslin
and draping.

*L & B Albums Frames Backgrounds Plus, Inc.
(www.lbalbumframe.com)*—Big selection, all types.

Mad Camp Artistic Backgrounds (www.madcamp.biz)

Photography Props.com (www.photographyprops.com)

The Prop Store of London (www.propstore.com)—Props
from movies.

Victorialyn (www.victorialyn.com)—Props and clothing.

Wicker by Design (www.wickerbydesign.com)—Props.

Book Production

These companies will print as few as one copy. Note that
the quality may vary between companies, mostly accord-
ing to price.

AsukaBook USA (www.asukabook.com)—Leather covers.

Blurb (www.blurb.com)

Marathon Press (www.marathonpress.com)

McKenna Pro (www.mckennapro.com)

My Publisher (www.mypublisher.com)

Photo Book Canada (www.photobookcanada.com)

Pikto (www.pikto.com)

SharedInk (www.sharedink.com)

Shutterfly (www.shutterfly.com)

Snapfish (www.snapfish.com)

Viovio (www.viovio.com)—Square books in eight sizes.

Winkflash (www.winkflash.com)

Business Plan

*Palo Alto Software (www.bplans.com/photography_
studio_business_plan)*

Camera Bags

Boda (www.goboda.com)—Lens bags.

Jill-e Designs, LLC (www.jill-e.com)

Lowepro (www.lowepro.com)

Tamrac (www.tamrac.com)

Tutto (www.tutto.com)

Cameras, Lenses, and other Photo Equipment

Note: Shop around for the best buy. There are several ad-
ditional sites on the Internet that sell equipment.

Arlington Camera (www.arlingtoncamera.com)

B&H Photo and Video (www.bhphoto.com)

Calumet (www.calumetphoto.com)

eStudio Lighting (www.estudiolighting.com)

Glazer's (www.glazerscamera.com)

Midwest Photo Exchange (www.mpex.com)

Precision Camera (www.precision-camera.com)

Samy's Camera (www.samys.com)

Showcase (www.showcaseinc.com)

The Camera Exchange, Inc. (www.camerax.com)

Unique Photo (www.uniquephoto.com)

Clothing (and Angel Wings) for Portraits

American Photographic Resources (www.aprprops.com)

Backdrop Outlet (www.backdropoutlet.com)

*Barnes Children's Portrait Clothing (www.barnes
portraitclothing.com)*

Posh Props (www.poshprops.com)

Victoralyn (www.victorialyn.com)

Community Involvement

Baby Angel Pics (www.babyangelpics.com)

Heart Gallery (www.sacheartgallery.org)—Foster child photography. One regional web site.

Now I Lay Me Down to Sleep (www.nowilaymedownto sleep.org)

Special Kids Photography of America (www.specialkids photography.com)—Ambassador program, workshops.

Sparrow Clubs (www.sparrowclubs.org)

Computer Hardware

Wacom Technology (www.wacom.com)—Graphics tablet.

Copyright-Free Clip Art

Dover Publications (www.doverpublications.com/dspa023)

Contests

Links to contests: www.prosphotos.com

Display Units

Godfrey Group, Inc. (www.godfreygroup.com)—Units for community displays.

Equipment, Misc.

Veach Co. (www.veachco.com)—Die cutting and hot-stamping machines.

Person & Person (www.personandperson.com)—Laminators.

Framing

B&S Frames (www.coversandcorners.com)

Excel (www.excelpictureframes.com)

GNP (www.gnpframe.com)

GW Moulding (www.gwmoulding.com)

Handbags

Bags by Babycakes (www.bagsbybabycakes.com)

Contessa (www.contessabags.com)

Gina Alexander (www.ginaalexander.com)

McKenna Pro (www.mckennapro.com)—Styles with replaceable photo image flaps.

Snaptotes (www.snaptotes.com)

Imaging Software

Note: Most of the following products are Photoshop add-ons or plug-ins, indicated with PS.

Adobe Photoshop (www.adobe.com)—Image correction and enhancement.

Adobe Photoshop Elements (www.adobe.com)—Image correction, some enhancement.

Adobe Photoshop Lightroom (www.adobe.com)—PS, mostly image correction. Plug-ins for enhancement available in Lightroom.

Capture NX (www.capturenx.com)—Image correction, does not require Photoshop.

Craig's Actions (www.craigsactions.com)—PS, image enhancement.

Kubota Image Tools (www.kubotaimagetools.com)—PS, mostly enhancement, some frames.

LucisArt (www.lucisart.com)—PS, enhancement.

Nik Software, Inc. (www.niksoftware.com)—PS, mostly enhancement.

OnOne Software (www.ononesoftware.com)—PS, enhancement, improve enlargement quality, frames.

Photomatix (www.hdrsoft.com)—HDR tone mapping.

Information, Forums, Resources, and Blog Sites

Canon Digital Photography Forums (http://photography-on-the.net/forum/showthread.php?t=458053)

Digital Grin (www.dgrin.com)

Digital Pixels (www.digitalpixels.net)

Digital Photography Review (www.dpreview.com)

Digital Wedding Forum (www.digitalweddingforum.com)

DIY Photography (www.diyphotography.net)

eHow (www.ehow.com)

Flickr (www.flickr.com)

I Love Photography (http://ilovephotography.com/forums /index.php)

Links to photographic subjects (www.prosphotos.com)—Contests, equipment, blogs, etc.

No BS Photo Success (www.nobsphotosuccess.com)

Photoethnography (www.photoethnography.com)—Solid information that mixes old with new.

Photographic Suppliers (www.kimmccormick.com/ photographicsuppliers.htm)

Pro4um (www.pro4um.com www.pro4um.com)— Subscription-based pro. photographer e-zine.

Strobist (www.strobist.com)—Lighting information.

The Photo Forum (www.thephotoforum.com)

Tutorials (http://digital-photography-school.com/25-great-photography-tutorials-and-links-from-around-the-web)

Internet (Blog, Web Design) Posting Services

Blu Domain (www.bludomain.com)—Web design.

Collages (www.collages.net)—Posting service.

Dirt Cheap Web Designs (www.dirtcheap4u.com)

Lab Prints (www.labprints.com)—Posting service.

Marathon Press (www.marathonpress.com)— Web design.

Pictage (www.pictage.com)—Posting service.

Spitfire (www.spitfirephoto.com)—Posting service.

WordPress (www.wordpress.com)—Blog.

You Select It (www.youselectit.com)—Posting service store front.

Insurance Programs

Hill & Usher Insurance for Photographers (www.package choice.com)

PPA (www.ppa.com)—Errors and omissions.

Jewelry

Kimbra Studios (www.kimbrastudios.com)

McKenna Pro Silverscape Jewelry (www.mckennapro.com)

Vogel Studio (www.vogelstudio.com)

Labels and Stickers

4 Color Print (DGI) (www.4colorprint.com)

Consolidated Label Co. (www.consolidatedlabel.com)

Enhanced Images (www.enhancedimages-labels.com)

Frontier Label (www.frontierlabel.com)

Vista Print (www.vistaprint.com)

Lighting (Continuous, Flash, and Strobe)

Alien Bees (www.alienbees.com)—Flash.

Cowboy Studio (www.cowboystudio.com)

Denny Manufacturing (www.dennymfg.com)—Flash.

eStudio Lighting (www.estudiolighting.com)—Continuous and strobe.

F. J. Westcott Lighting (www.fjwestcott.com)— Continuous kit with modifier and stand.

Lumedyne, Inc. (www.lumedyne.com)—Flash.

Owens (www.owens-originals.com)—Continuous and strobe.

Photogenic (www.photogenicpro.com)—Strobe.

Quantum Instruments (www.quantuminstruments.com)—Flash.

Savage Universal (www.savagepaper.com)—All types.

Light Meters

Sekonic (www.sekonic.com)

Light Modifiers (Small and Large)

Gary Fong Products (www.garyfonginc.com)—Small.

Hughes (www.ppmag.com/web-exclusives/2007/10/ hughes-soft-light-reflector.html)—Small.

Lumiquest Products (www.lumiquest.com)—Small.

F. J. Westcott (www.fjwestcott.com)—Large and small.

Larsen Enterprises (www.larsen-ent.com)—Modifiers for strobes.

OBN Photography Equipment (www.obnphoto.com)— Tents.

Pix Inc. (www.pixcamera.com)—Lighting rentals.

Marketing Books, Seminars, and Webinars

Creative Marketing Workbook by Ana Brandt (www.anabrandt.com)

The Kathleen Hawkins Guide to Sales and Marketing for Professional Photographers (www.amherst media.com)

Marathon Press (www.marathonpress.com)—Seminars.

McKenna Pro (www.mckennapro.com)—Tips on web site/webinars.

Power Marketing, Selling, and Pricing (2nd ed.) by Mitche Graf (www.amherstmedia.com)

Professional Marketing and Selling Techniques for

Wedding Photographers (2nd ed.) *by Kathleen Hawkins (www.amherstmedia.com)*

Music for DVDs and Presentations

Note: The following sites offer royalty-free downloads for purchase.

Royalty Free Music (www.royaltyfreemusic.com)
Mad Camp (www.madcamp.biz)
Music 2 Hues (www.music2hues.com)
Stock 20 (www.stock20.com)
Triple Scoop Music (www.triplescoopmusic.com)—
 Especially for photographers.

Novelties and Advertising Give-Aways

All Starz Photo (www.allstarzphoto.com)
Fun Photo Biz (www.funphotobiz.com)
*Pexagon (www.pexagontech.com)—*Personalized flash drives and pocket-sized external hard drives.
Denny Novelty (www.photonovelty.com)

Packaging, Folders, Paper Goods

*B & C Photo Supply (www.bcphotosupply.com)—*Folios, boxing, packaging.
Bella Graphica (www.bellagraphica.com)
*Casi-QLT (www.qlt.com)—*Frames, folders.
DNL Photo (www.dnlphoto.com)
Envelopements (www.envelopements.com)
*H B Packaging (www.h-bphoto.com)—*Presentation boxes, DVD folios.
*Pro Studio Supply (www.prostudiousa.com/Photo-Packaging-C79.aspx)—*Boxes, envelopes, bags.
*Rice Studio Supply (www.ricestudiosupply.com)—*Boxes, bags, folios, tissue.
*Studio Style by Collector's Gallery (www.studiostyle.com)—*Folders, photo gifts.
*Uline (www.uline.com)—*Corrugated stock, bags.
*Xpedx (www.xpedx.com)—*Packing matrials.

Photofinishing Labs

American Color Imaging (ACI) (www.acilab.com)
Bay Photo Lab (www.bayphoto.com)
*BWC (www.bwc.net)—*Black & white prints.

Canvas On Demand (www.canvasondemand.com)
Color Incorporated (www.colorincprolab.com)
H & H Color Lab (www.hhcolorlab.com)
McKenna Pro (www.mckennapro.com)
Mpix (www.mpix.com)
Pounds Photographic Labs (www.poundslab.com)
Simply Canvas (www.simplycanvas.com)

Photographic Papers

Epson America, Inc. (www.epson.com)
Moab (www.moabpaper.com)
Savage Universal (www.savagepaper.com)

Photo Printers

Epson America, Inc. (www.epson.com)
Hewlett Packard (www.hp.com)
Kodak (www.kodak.com)

Presentation Software

Pro Select by Time Exposure (www.timeexposure.com)
PhotoDex ProShow Slide Show (www.photodex.com)

Press Printing

Postcards, business cards, etc.

4-Color Print (www.4colorprint.com)
48 Hour Print (www.48hourprint.com)
48 Hr. Print (www.48hrprint.com)
Blossom Publishing (www.blossom-publishing.com)
Full Color (www.fullcolor.com)
Marathon Press (www.marathonpress.com)
McKenna Pro (www.mckennapro.com)
Overnight Prints (www.overnightprints.com)
Postcard Press (www.postcardpress.com)
PS Print (www.psprint.com)
Styleart (www.styleart.com)
Vista Print (www.vistaprint.com)
White House Custom Color (www.whcc.com)

Print Cases

For shipping 16x20-inch prints to competition judges.

Adorama (www.adorama.com)

Reflectors and Diffusers

Adorama (www.adorama.com)

Amazon (www.amazon.com/Westcott-Photo-Basics 304-Reflector/dp/B000N4AYHC)

F. J. Westcott (www.fjwestcott.com)

Larson Enterprises (larson-ent.com)

Photography-lighting.com (www.photography-lighting.com/reflectors.html)

Reflector Information (www.expertvillage.com/video/2350_photography-reflectors-diffusers.htm)

Claude Jodoin web site (www.claudejodoin.com) Lighting DVDs available.

Rentals

Calumet Photographic (www.calumetphoto.com)

Digital Transitions (www.digitaltransitions.com/digital-equipment-rentals.php)

DPI (www.dpi-digitalphoto.com/termsofrental.php)

Pix Inc. (www.pixcamera.com)

Samy's Camera (www.samyscamera.com)

Tempe Camera (www.tempecamera.biz)

Retouching and Restoration

Hollywood FotoFix (www.hollywoodfotofix.com)

Ron Nichols (www.ronnichols.com)

Schools of Photography

Academy of Art University (www.academyart.edu)

Brooks Institute (www.brooks.edu)

New England School of Photography (www.nesop.com)

New York Institute of Photography (www.nyip.com)

Scrapbook Stores/Departments

Scrapbook stores/departments are great places to browse and find adornments for canvas prints, albums, etc.

JoAnn Etc. (www.joann.com)

Michaels (www.michaels.com)

Scrapbook.com (www.scrapbook.com)

Studio Management Software

Photo One Software (www.photoonesoftware.com)

Studio Plus Software (www.studioplussoftware.com)

Success Ware (www.successware.net)

Tripods/Monopods

Induro (www.indurogear.com)

Manfrotto (www.manfrotto.com)

Sony (www.sonystyle.com)

Product reviews (www.photographywebsite.co.uk/tripods-c232.html)

Wireless Triggers

Pocket Wizard (www.pocketwizard.com)

Speedotron (www.speedotron.com)

Quantum Instruments Inc. (www.qtm.com)

White Balancing Products

Clear White (www.digitalphotographykits.com)

Expo Imaging (www.expodisc.com)—ExpoDisc.

Lally Cap (www.lallyphotography.com/store)

Phoxle SpectraSnap (www.phoxle.com)

Melitta Filter (www.amazon.com) Don't scoff. Coffee filters are very highly rated in WB performance!

Mennon White Balance Lens Cap (www.mennon-usa.com)

Warm Cards—www.warmcards.com

Workflow

Breeze Systems (www.breezesys.com)

Workshops

Drake Busath (http://italyworkshops.busath.com)

Golden Gate School (www.goldengateschool.org)

Image Explorations (www.imageexplorations.ca)

Kevin Kubota (www.kubotaimagetools.com)

Lightpro Expo (www.lightproexpo.com)

Mitche Graf (www.thepassionatelife.org)—Photo business.

Marathon Press (www.marathonpress.com)—Marketing.

Senior Portrait Artist (www.spartists.com)

Special Kids Photography of America (www.specialkidsphotography.com)

Texas School (www.texasschool.org)

West Coast School (www.prophotoca.com/wcs)

Index

PHOTOGRAPHING CHILDREN WITH SPECIAL NEEDS

Karen Dórame

This book explains the symptoms of spina bifida, autism, cerebral palsy, and more, teaching photographers how to safely and effectively work with clients to capture the unique personalities of these children. $29.95 list, 8.5x11, 128p, 100 color photos, order no. 1749.

POSING TECHNIQUES FOR PHOTOGRAPHING MODEL PORTFOLIOS

Billy Pegram

Learn to evaluate your model and create flattering poses for fashion photos, catalog and editorial images, and more. $34.95 list, 8.5x11, 128p, 200 color images, index, order no. 1848.

SIMPLE LIGHTING TECHNIQUES

FOR PORTRAIT PHOTOGRAPHERS

Bill Hurter

Make complicated lighting setups a thing of the past. In this book, you'll learn how to streamline your lighting for more efficient shoots and more natural-looking portraits. $34.95 list, 8.5x11, 128p, 175 color images, index, order no. 1864.

PHOTOGRAPHER'S GUIDE TO

WEDDING ALBUM DESIGN AND SALES, 2nd Ed.

Bob Coates

Learn how industry leaders design, assemble, and market their albums with the insights and advice in this popular book. $34.95 list, 8.5x11, 128p, 175 full-color images, index, order no. 1865.

LIGHTING FOR PHOTOGRAPHY TECHNIQUES FOR STUDIO AND LOCATION SHOOTS

Dr. Glenn Rand

Gain the technical knowledge of natural and artificial light you need to take control of every scene you encounter and produce incredible photographs. $34.95 list, 8.5x11, 128p, 150 color images/diagrams, index, order no. 1866.

SCULPTING WITH LIGHT

Allison Earnest

Learn how to design the lighting effect that will best flatter your subject. Studio and location lighting setups are covered in detail with an assortment of helpful variations provided for each shot. $34.95 list, 8.5x11, 128p, 175 color images, diagrams, index, order no. 1867.

STEP-BY-STEP WEDDING PHOTOGRAPHY

Damon Tucci

Deliver the the top-quality images your clients demand with the tips in this essential book. Tucci shows you how to become more creative, more efficient, and more successful. $34.95 list, 8.5x11, 128p, 175 color images, index, order no. 1868.

ROLANDO GOMEZ'S

POSING TECHNIQUES FOR GLAMOUR PHOTOGRAPHY

Learn everything you need to pose a subject—from head to toe. Gomez covers each area of the body in detail, showing you how to address common problems and create a flattering look. $34.95 list, 8.5x11, 128p, 110 color images, index, order no. 1869.

PROFESSIONAL WEDDING PHOTOGRAPHY

Lou Jacobs Jr.

Jacobs explores techniques and images from over a dozen top professional wedding photographers in this revealing book, taking you behind the scenes and into the minds of the masters. $34.95 list, 8.5x11, 128p, 175 color images, index, order no. 2004.

THE ART OF CHILDREN'S PORTRAIT PHOTOGRAPHY

Tamara Lackey

Learn how to create images that are focused on emotion, relationships, and storytelling. Lackey shows you how to engage children, conduct fun and efficient sessions, and deliver images that parents will cherish. $34.95 list, 8.5x11, 128p, 240 color images, index, order no. 1870.

EVENT PHOTOGRAPHY HANDBOOK

W. Folsom and J. Goodridge

Learn how to win clients and create outstanding images of award ceremonies, grand openings, political and corporate functions, and other special occasions. $34.95 list, 8.5x11, 128p, 150 color images, index, order no. 1871.

50 LIGHTING SETUPS FOR PORTRAIT PHOTOGRAPHERS

Steven H. Begleiter

Filled with unique portraits and lighting diagrams, plus the "recipe" for creating each one, this is a resource you'll rely on for many portrait situations and subjects. $34.95 list, 8.5x11, 128p, 150 color images and diagrams, index, order no. 1872.

DIGITAL PHOTOGRAPHY BOOT CAMP, 2nd Ed.

Kevin Kubota

This popular book based on Kevin Kubota's sell-out workshop series is now fully updated with techniques for Adobe Photoshop and Lightroom. It's a down-and-dirty, step-by-step course for professionals! $34.95 list, 8.5x11, 128p, 220 color images, index, order no. 1873.

LIGHTING AND PHOTOGRAPHING
TRANSPARENT AND TRANSLUCENT SURFACES

Dr. Glenn Rand

Learn to photograph glass, water, and other tricky surfaces in the studio or on location. $34.95 list, 8.5x11, 128p, 125 color images, diagrams, index, order no. 1874.

100 TECHNIQUES FOR PROFESSIONAL WEDDING PHOTOGRAPHERS

Bill Hurter

Top photographers provide tips for becoming a better shooter—from optimizing your gear, to capturing perfect moments, to streamlining your workflow. $34.95 list, 8.5x11, 128p, 180 color images and diagrams, index, order no. 1875.

BUTTERFLY PHOTOGRAPHER'S HANDBOOK

William B. Folsom

Learn how to locate butterflies, approach without disturbing them, and capture spectacular, detailed images. $34.95 list, 8.5x11, 128p, 175 color images, index, order no. 1877.

DOUG BOX'S
GUIDE TO POSING
FOR PORTRAIT PHOTOGRAPHERS

Based on Doug Box's popular workshops for professional photographers, this visually intensive book allows you to quickly master the skills needed to pose men, women, children, and groups. $34.95 list, 8.5x11, 128p, 200 color images, index, order no. 1878.

500 POSES FOR PHOTOGRAPHING WOMEN

Michelle Perkins

A vast assortment of inspiring images, from head-and-shoulders to full-length shots, and classic to contemporary styles—perfect for when you need a little shot of inspiration to create a new pose. $34.95 list, 8.5x11, 128p, 500 color images, index, order no. 1879.

POWER MARKETING, SELLING, AND PRICING
A BUSINESS GUIDE FOR WEDDING AND PORTRAIT PHOTOGRAPHERS, 2ND ED.

Mitche Graf

Master the skills you need to take control of your business, boost your bottom line, and build the life you want. $34.95 list, 8.5x11, 144p, 90 color images, index, order no. 1876.